D1120546

Children Map the World

Selections from the Barbara Petchenik
Children's World Map Competition

Children Map the World

Selections from the Barbara Petchenik Children's World Map Competition

Carla Cristina R. G. de Sena, José Jesús Reyes Nuñez, Necla Uluğtekin, and Temenoujka Bandrova, editors

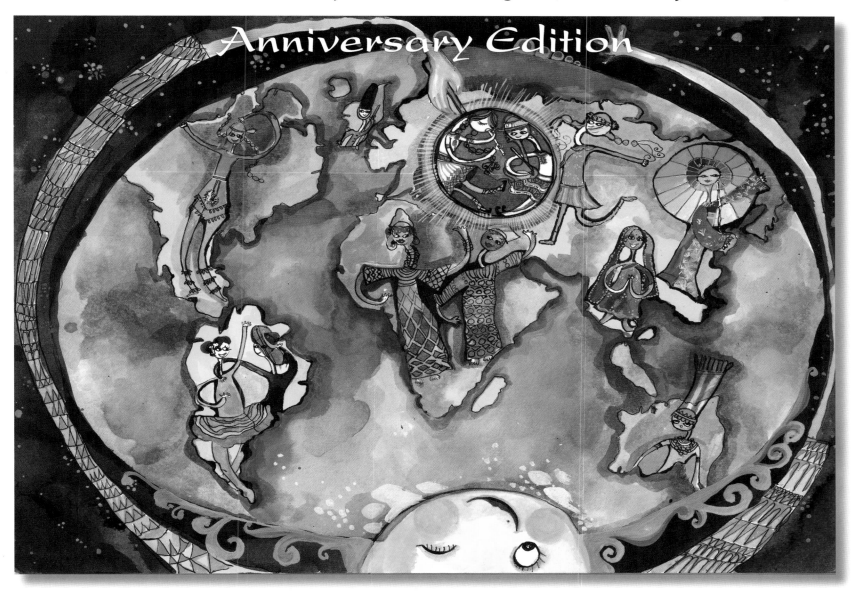

Anniversary Edition

Esri Press
REDLANDS | CALIFORNIA

Esri Press, 380 New York Street, Redlands, California 92373-8100

Copyright © 2015 Esri

All rights reserved.

Printed in the United States of America

19 18 17 16 15 1 2 3 4 5 6 7 8 9 10

The information contained in this document is the exclusive property of Esri unless otherwise noted. This work is protected under United States copyright law and the copyright laws of the given countries of origin and applicable international laws, treaties, and/or conventions. No part of this work may be reproduced or transmitted in any form or by any means, electronic or mechanical, including photocopying or recording, or by any information storage or retrieval system, except as expressly permitted in writing by Esri. All requests should be sent to Attention: Contracts and Legal Services Manager, Esri, 380 New York Street, Redlands, California 92373-8100, USA.

The information contained in this document is subject to change without notice.

US Government Restricted/Limited Rights: Any software, documentation, and/or data delivered hereunder is subject to the terms of the License Agreement. The commercial license rights in the License Agreement strictly govern Licensee's use, reproduction, or disclosure of the software, data, and documentation. In no event shall the US Government acquire greater than RESTRICTED/LIMITED RIGHTS. At a minimum, use, duplication, or disclosure by the US Government is subject to restrictions as set forth in FAR §52.227-14 Alternates I, II, and III (DEC 2007); FAR §52.227-19(b) (DEC 2007) and/or FAR §12.211/12.212 (Commercial Technical Data/Computer Software); and DFARS §252.227-7015 (DEC 2011) (Technical Data – Commercial Items) and/or DFARS §227.7202 (Commercial Computer Software and Commercial Computer Software Documentation), as applicable. Contractor/Manufacturer is Esri, 380 New York Street, Redlands, CA 92373-8100, USA.

@esri.com, 3D Analyst, ACORN, Address Coder, ADF, AML, ArcAtlas, ArcCAD, ArcCatalog, ArcCOGO, ArcData, ArcDoc, ArcEdit, ArcEditor, ArcEurope, ArcExplorer, ArcExpress, ArcGIS, arcgis.com, ArcGlobe, ArcGrid, ArcIMS, ARC/INFO, ArcInfo, ArcInfo Librarian, ArcLessons, ArcLocation, ArcLogistics, ArcMap, ArcNetwork, *ArcNews*, ArcObjects, ArcOpen, ArcPad, ArcPlot, ArcPress, ArcPy, ArcReader, ArcScan, ArcScene, ArcSchool, ArcScripts, ArcSDE, ArcSdl, ArcSketch, ArcStorm, ArcSurvey, ArcTIN, ArcToolbox, ArcTools, ArcUSA, *ArcUser*, ArcView, ArcVoyager, *ArcWatch*, ArcWeb, ArcWorld, ArcXML, Atlas GIS, AtlasWare, Avenue, BAO, Business Analyst, Business Analyst Online, BusinessMAP, CityEngine, CommunityInfo, Database Integrator, DBI Kit, EDN, Esri, esri.com, Esri—Team GIS, Esri—*The GIS Company*, Esri—The GIS People, Esri—The GIS Software Leader, FormEdit, GeoCollector, Geographic Design System, Geography Matters, Geography Network, geographynetwork.com, Geoloqi, Geotrigger, GIS by Esri, gis.com, GISData Server, GIS Day, gisday.com, GIS for Everyone, JTX, MapIt, Maplex, MapObjects, MapStudio, ModelBuilder, MOLE, MPS—Atlas, PLTS, Rent-a-Tech, SDE, SML, Sourcebook•America, SpatiaLABS, Spatial Database Engine, StreetMap, Tapestry, the ARC/INFO logo, the ArcGIS Explorer logo, the ArcGIS logo, the ArcPad logo, the Esri globe logo, the Esri Press logo, The Geographic Advantage, The Geographic Approach, the GIS Day logo, the MapIt logo, The World's Leading Desktop GIS, *Water Writes*, and Your Personal Geographic Information System are trademarks, service marks, or registered marks of Esri in the United States, the European Community, or certain other jurisdictions. CityEngine is a registered trademark of Procedural AG and is distributed under license by Esri. Other companies and products or services mentioned herein may be trademarks, service marks, or registered marks of their respective mark owners.

Ask for Esri Press titles at your local bookstore or order by calling 800-447-9778, or shop online at esri.com/esripress. Outside the United States, contact your local Esri distributor or shop online at eurospanbookstore.com/esri.

Esri Press titles are distributed to the trade by the following:

In North America:
Ingram Publisher Services
Toll-free telephone: 800-648-3104
Toll-free fax: 800-838-1149
E-mail: customerservice@ingrampublisherservices.com

In the United Kingdom, Europe, Middle East and Africa, Asia, and Australia:
Eurospan Group
3 Henrietta Street
London WC2E 8LU
United Kingdom

Telephone: 44(0) 1767 604972
Fax: 44(0) 1767 601640
E-mail: eurospan@turpin-distribution.com

Cover map:
Happy Earth Is Music to Our Ears
Ada Maria Ciontu
9
Romania
2013

Dedicated to all those colleagues without whom the International Cartographic Association would not have been able to organize the first competition in 1993.

Acknowledgments

The editors would like to express their gratitude to our colleague, Jeet Atwal, now retired from the Carleton University Library (Canada), and an enthusiastic founder of the Barbara Petchenik Children's Map Collection. We are also grateful to her colleagues Sylvie Lafortune (head of Maps, Data and Government Information Centre), and Joel Rivard and Sherri Sunstrum, who continue to update the collection and its website. We appreciate their collaboration, scanning the entries selected for this book. We also acknowledge the valuable work by the international coordinator of the competition, Peter van der Krogt (the Netherlands), who is responsible for collecting and scanning all the entries sent by participating countries to each competition. We wish to thank the International Cartographic Association's national representatives for organizing the competition in their countries as well as the specialists who select the winning national entries. Finally, our deepest appreciation and most sincere thanks to all the teachers worldwide who guide and direct their pupils who make the maps and drawings in their classrooms. Without these guiding lights, neither the competition nor this book would be realities.

Introduction

Carla Cristina R. G. de Sena, José Jesús Reyes Nuñez, Necla Uluğtekin, and Temenoujka Bandrova, editors

The International Cartographic Association (ICA) has held the Barbara Petchenik Children's World Map Competition every two years since 1993. The 2013 competition culminated at the 11th International Exhibition during the 26th International Cartographic Conference in Dresden, Germany.

The competition primarily aims to promote the way children creatively represent the world while enhancing their cartographic awareness and consciousness of their environment. The ICA Commission on Cartography and Children supports the event as a way to introduce the power of maps to children. Its goals are to promote the enjoyment of maps by children, increase the awareness of how they interact with maps, and raise the standards of maps and atlases designed for children.

In addition to these primary tasks, the commission creates rules for the competition and offers support to any child who seeks guidance along the way. The commission also supports organizers involved in the national and international competitions and exhibitions, and invites colleagues from the ICA and other international organizations to serve on the Judging Commission responsible for selecting the winning entries.

The biennial competition is divided into two levels. The first level is the national competition, organized by participating ICA member countries. The jury named by the national organizers selects a maximum of six winners who represent their countries at the second level—the international competition.

The ICA, its Commission on Cartography and Children, and local organizers worked intently to improve the eleventh exhibition in the months leading up to 2013 competition. During this time, they selected the competition theme, "My Place in Today's World," proposed by Professor Rosangela Doin de Almeida of Brazil. The selection of this theme, which gives children a starting point for the message

they want to convey, came after a public voting process involving forty-seven cartographers, geographers, GIS specialists, teachers, and other specialists from twenty countries.

For the 2013 competition, ICA members voted to increase the number of age categories for awards. Previously, the International Jury awarded prizes in three age categories (under 9, 9–12, and 13–15). For 2013, children received awards in four categories (under 6, 6–8, 9–12, and 13–15; in this volume, the under 6 and 6–8 categories are combined in one section). During the 26th International Cartographic Conference in 2013, the jury selected twelve winning drawings (three awards per age category) and made one special mention to honor the outstanding quality and message of one entry in the oldest age group. In addition, visitors to the exhibition voted on a public award for the best overall entry, for a total of fourteen prizes, which are indicated with an "award logo" on the respective pages of this book.

Children's drawings

Everyone involved in the competition the past twenty years made the same observation: while each competition may seem similar to previous ones, each of them, in fact, is quite different, in that the drawings always seemed to reveal hidden surprises upon close examination. The 2013 competition was not an exception, making it extremely difficult for the four editors to select the fifty drawings for this volume.

The competition drew one hundred and fifty-five entries from thirty countries across five continents. A common characteristic of the entries was the challenge to represent the same theme with a diversity of personal and original solutions.

Drawings made by children can represent a positive message designed with internationally recognizable motives such as "Friendship," created by Greta Aželytė, 13, from Lithuania, on page 41; as well as a more sobering and cautionary messages such as "Angry Earth," by Abdan Ataqillah, 4, from Indonesia, on page 3.

The drawings in this collection vary on a range between vivid colors and black and white to enhance the represented theme. Two examples are the drawings "My Place in Today's World Is a World Where Friends Are Very Important to Me," created by Keagen Madodzi, 5, of South Africa on page 5; and "Peace & Harmony," by Wang Zhiling, 12, of China, on page 30.

One of the always interesting representations for a "Western cartographer" is when children from other latitudes draw the continents by placing their countries or regions in the center of their maps, a choice used often in Asia or Australia, as can be appreciated on the map titled, "A World of Fruits," created by Rebecca Heggers, then 13, of Australia in 1999, on page 64; or in the "Wonderful World," painted by Lu Yuxin, 10, from China in 2013, on page 19.

Readers will find many small (and not so small) artworks among the drawings: the maybe sad or just pensive face in a world map by Beatriz Froehner, 13, of Brazil, on page 38; the Earth hanging from the branch of a leafless tree in the work made by Jacob Dimla, 14, of Canada, on page 44; and the world map that Chloe Fan, 14, of Canada, used to decorate her violin on page 45.

The selections present many surprising expressions, including the world map traced using a single brush stroke in "To the One World," by Hazuki Ota, 13, of Japan, on page 40; the world map on a bookshelf in "World Section," by Amy Wang, 13, of New Zealand, on page 42; and one showing a girl holding

the Earth on her legs and examining it with a magnifying glass in "Happy Earth Is Music to Our Ears," by Ada Maria Ciontu, 9, of Romania, on the cover and page 17.

For those who appreciate more cartographic expressions, the editors recommend the 2001 map, "Last Chance to Save Our Planet," which was made on recycled paper to honor its title, by Grant Mayer, then 9, of the United States, on page 67; and the 2001 thematic map, "Globalized World," drawn by Beatriz Borroso Gstrein, then 12, of Spain, on page 75.

A very special anniversary

The 2013 Barbara Petchenik Competition was especially important because it was organized to celebrate the arrival of its "adulthood," exactly twenty years after the first competition in 1993. During those twenty years, children from sixty-three countries submitted nearly fifteen hundred entries in eleven international exhibitions. Except for the first competition (in which there were no national pre-selections and hundreds of entries arrived from twenty-seven countries), the highest number of entries for the competition (186) was exhibited in the 10th International Exhibition held in Paris in 2011, and the highest number of participating countries (36) was exhibited in 2007.

The ICA paid special tribute to the competition during its 26th International Cartographic Conference in Dresden, Germany. For this occasion, the 11th International Exhibition featured the original ten award-winning drawings of 1993. The exhibit gave participants who did not attend the inaugural conference and exhibition the opportunity to see these drawings in person for the first time.

In addition to the drawings from the 2013 competition, this special anniversary edition of *Children Map the World* features twenty drawings selected from the first ten competitions between 1993 and 2011. It was difficult to make this final selection because the overall quality of the entries would have made any one of them worthy of inclusion.

Remembering the past

Then-ICA President, D. R. Fraser Taylor of Canada, initiated and enthusiastically supported the idea for the contest. Fraser first proposed honoring the memory of Barbara Petchenik (the first woman vice president of the association) in the "Remembrance" published in issue 20 of the *ICA News* (October 1992), shortly after her death:

> *Barbara, throughout her career, had a strong interest in maps for children and, in commemorating her considerable contribution to the discipline and profession of cartography, the ICA intends to give special focus to this aspect of her work.*

The immediate result was the celebration of the first Barbara Petchenik Children's World Map Competition and Exhibition during the 16th International Cartographic Conference held in Cologne, Germany, May 3–9, 1993. Two years later, the ICA approved the formation of a Working Group dedicated to cartography and children, which became the Commission on Cartography and Children after the approval of the General Assembly in Ottawa, Canada, in 1999.

Taylor reported his experiences related to the first competition in issue 21 of the newsletter in May 1993:

This Conference was also the site of the first display of children's maps for the Barbara Petchenik Map Competition. Although time was short, twenty-seven countries submitted entries from which seventy-six (semi-)finalists were selected. The display of these maps was one of the most popular focal points for participants and it showed the imagination and dynamism of the young, together with some fascinating interpretations of the world as seen through the eyes of children.

The chairperson of the first Judging Commission for the winning entries was Alberta Auringer Wood of Canada. She recalled her activities in that same newsletter:

On Sunday night, I was asked to serve as the chair of an ad hoc committee to select the finalists in the Barbara Bartz Petchenik Children's Map Competition. The other members of the committee were Wanarat Thothong (Thailand), Ernő Csáti (Hungary), Corné van Elzakker (the Netherlands) and Jon Kimerling (USA)… Many hundreds of maps had been submitted, but we were selecting from seventy-six semi-finalists chosen by the ICA Executive. From these we eventually chose submissions from Sri Lanka, Brazil, USA, UK, Estonia, Hungary, Slovakia, Romania, Japan and Indonesia as the ten finalists… The maps chosen exhibited a global view, showed imagination, creativity, and uniqueness, as well as some artistic skill.

Planning the future

As we write this introduction, the start of the 2015 competition is under way in ICA member countries. The 12th International Exhibition will display a new collection of drawings during the 27th International Cartographic Conference in Rio de Janeiro, Brazil, August 23–28, 2015. The ICA plans no significant changes to the current rules or theme, "My Place in Today's World," continuing the practice begun in 2005 of using the same theme in two consecutive competitions.

Everyone involved in organizing the competition aims to develop the cartographic quality of entries from young students, with a special focus on the oldest age group (12–15 years). Readers can learn more about the competition via the ICA (http://icaci.org/petchenik/), the ICA Commission on Cartography and Children (http://lazarus.elte.hu/ccc/ccc.htm), and the commission's Facebook profile (https://www.facebook.com/icaccc).

The ICA well understands that the competition contributes to the continuity of our profession, representing a basic but much-needed transition between the current and future generations of cartographers. It is a powerful way to popularize maps among children, young people, and the public in general. For these reasons, the ICA will continue its clear and unwavering support of the competition, convinced that drawings made by children will continue to deserve the admiration of specialists, educators, and fans of maps and cartography all over the world.

Ages 8
and under

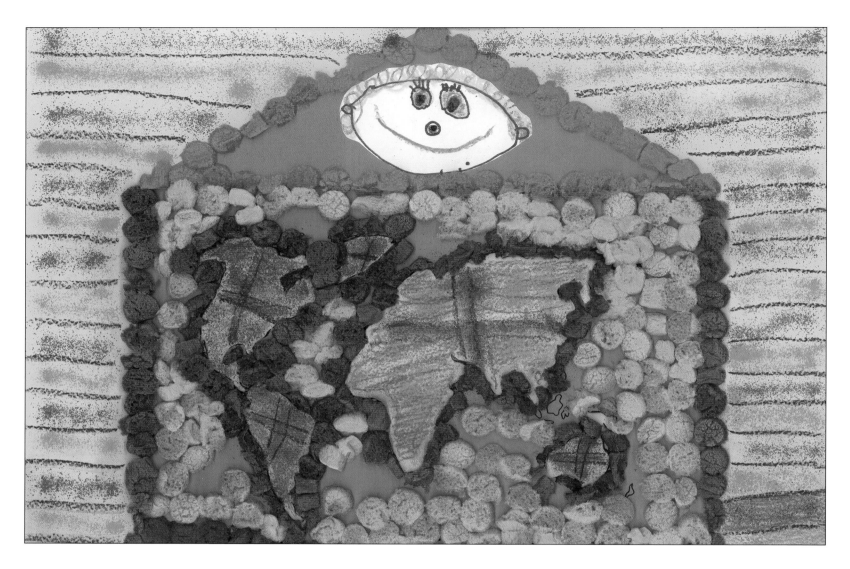

I Am at Home
Saulė Sinikovaitė
3
Lithuania
Jonavos lopšelis-darž elis 'Dobilas'
2013

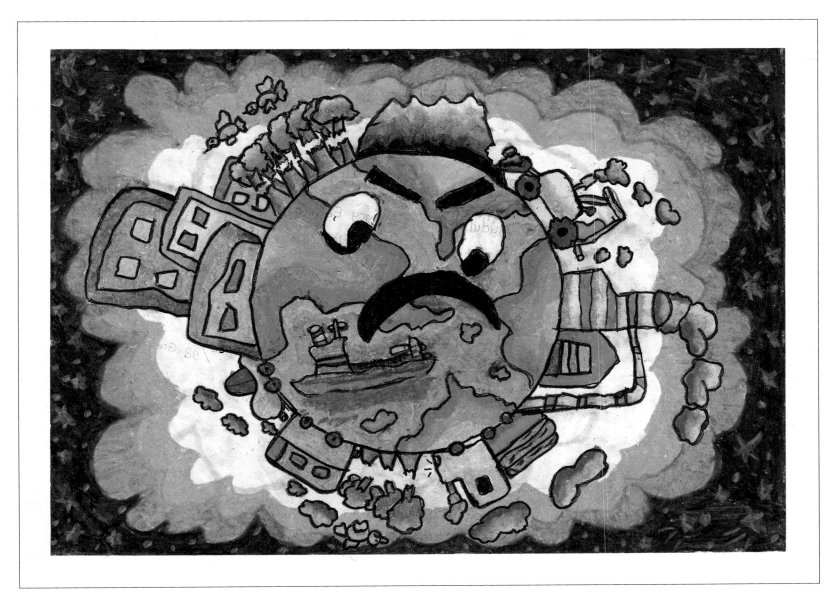

Angry Earth

Abdan Ataqillah

4

Indonesia

Gresik, East Java, Indonesia

2013

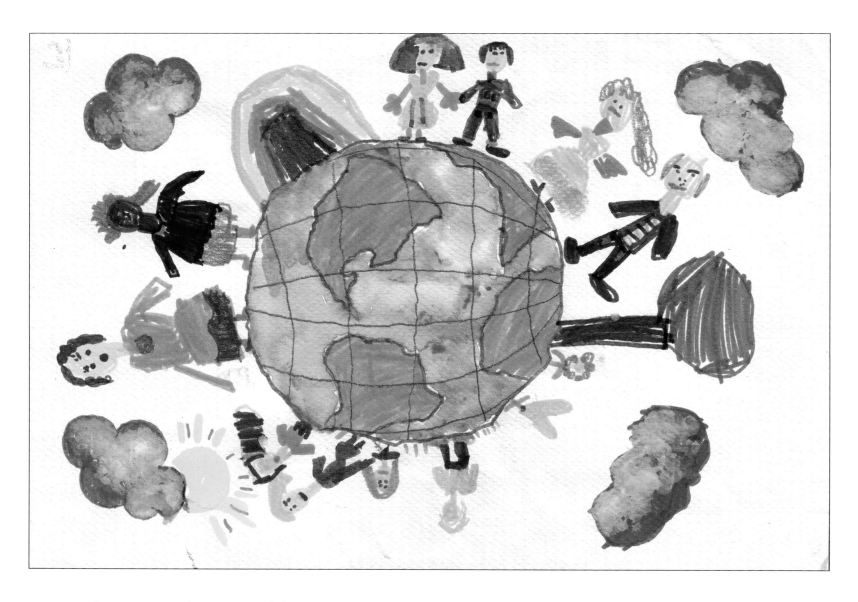

My Place in Today's World

Nora Rasmi

5

Iran

Tehran, Iran

2013

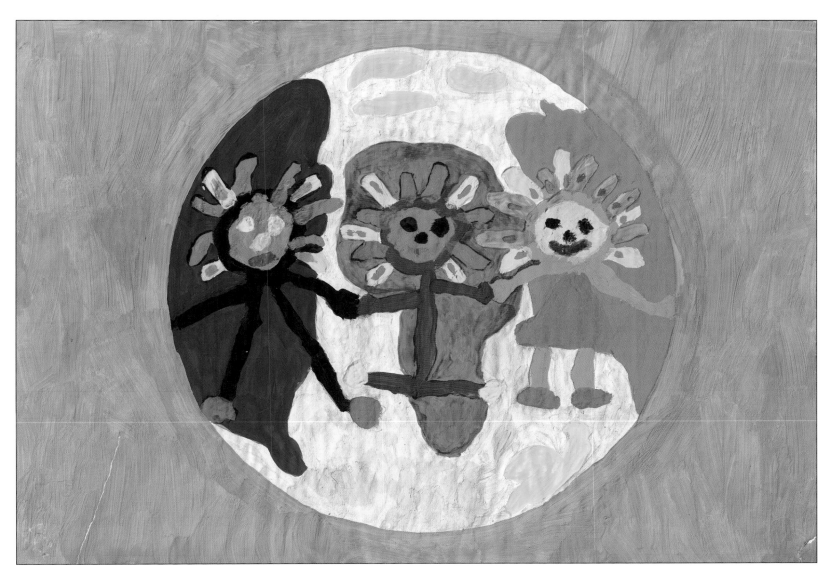

 My Place in Today's World Is a World Where Friends Are Very Important to Me
Keagen Madodzi
5
South Africa
"My Home" Children's Home
2013

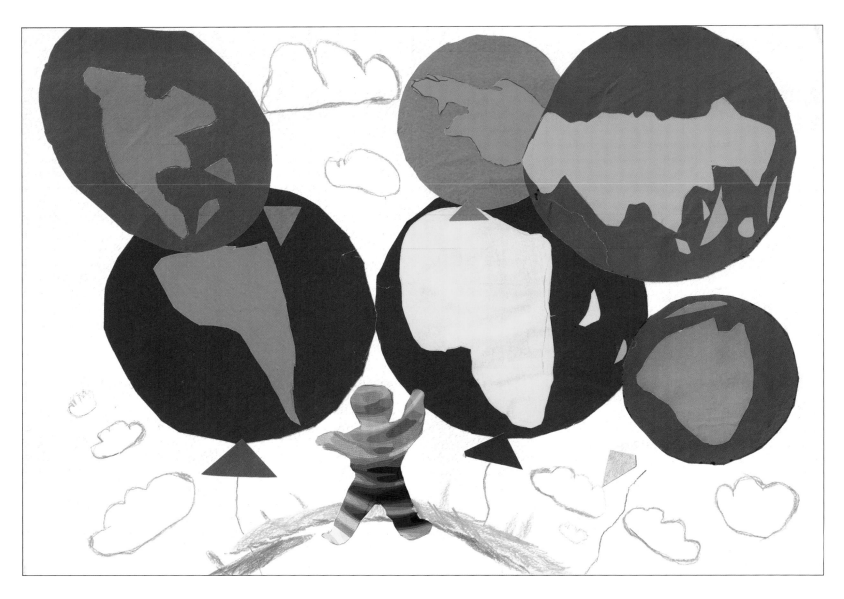

The Wide World Flies to Me
Nazar Stolyarov
5
Ukraine
Zhytomyr, Ukraine
2013

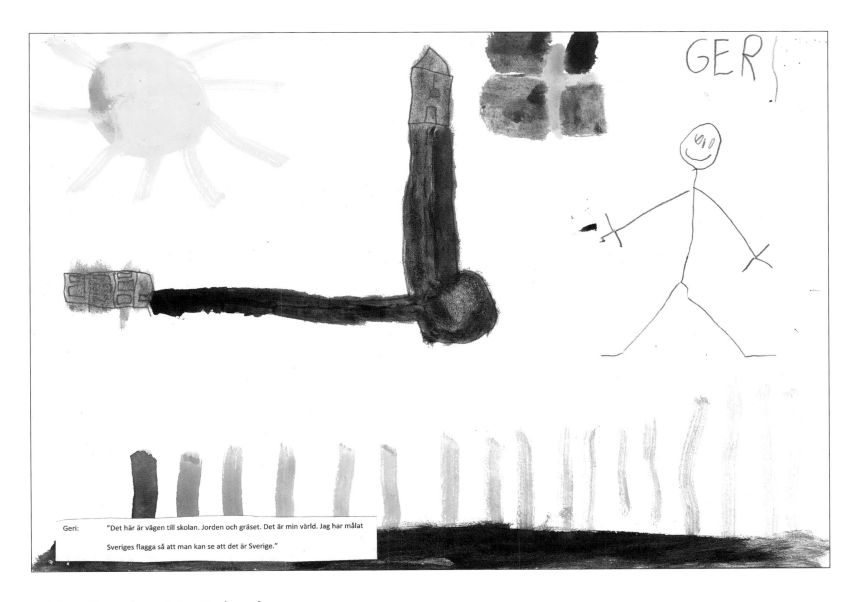

Geri: "Det här är vägen till skolan. Jorden och gräset. Det är min värld. Jag har målat

Sveriges flagga så att man kan se att det är Sverige."

The Road to My School
Geri Paci
6
Sweden
Fridhemsskolan FE
2013

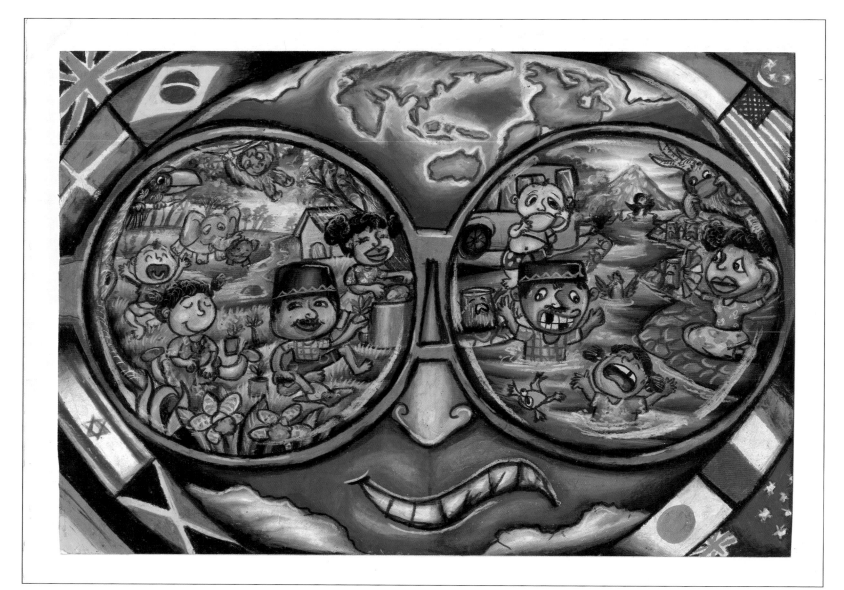

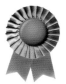

Good and Bad Sides of My Today's World

Zeva Su'azra Malaika

7

Indonesia

SD Al-Azhar 5 Kemandoran

2013

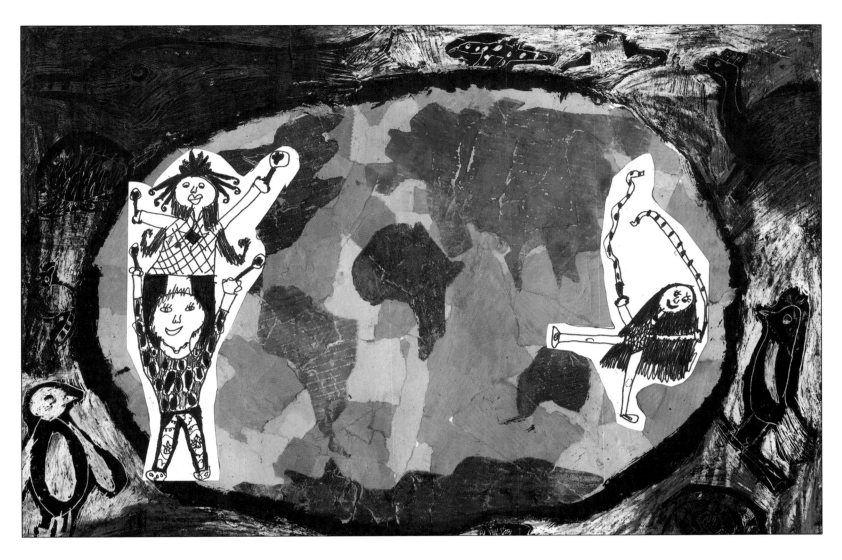

My Pleasure
Klará Gaššová
7
Slovakia
Základná umelecká škola F. Špániho
2013

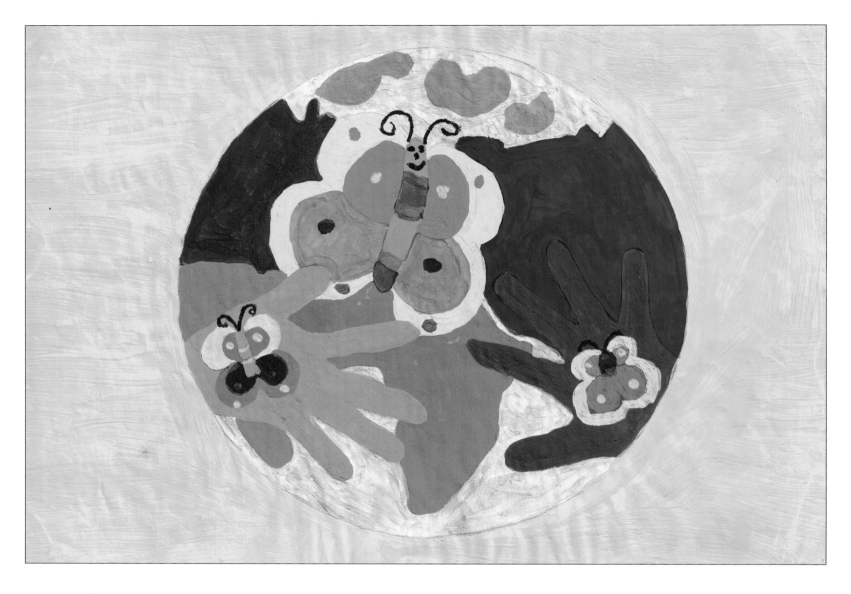

My Place in Today's World Is a World Where There Is No Racism
Abygail Motha
7
South Africa
"My Home" Children's Home
2013

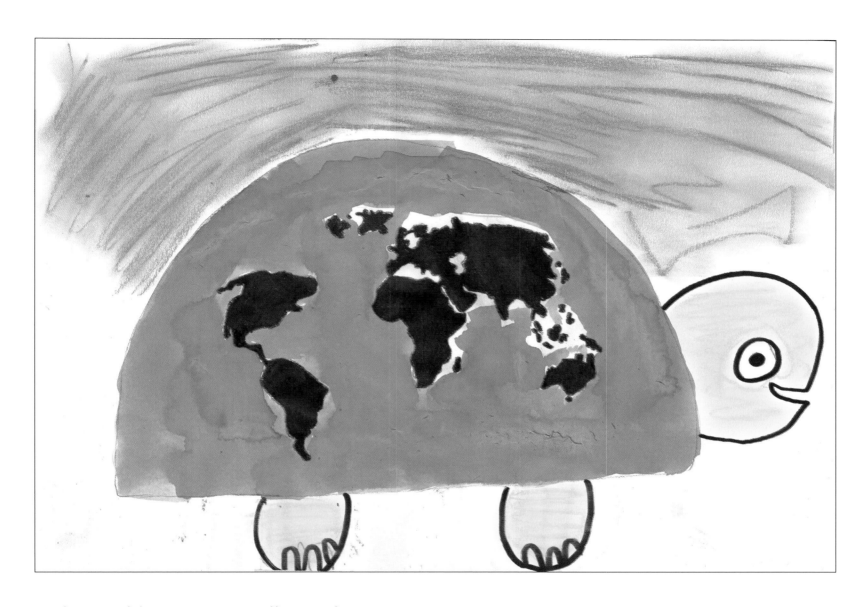

The World Carries Us All Together
Elsie Van Hellemont
8
Belgium
Tekenklas Houwaert
2013

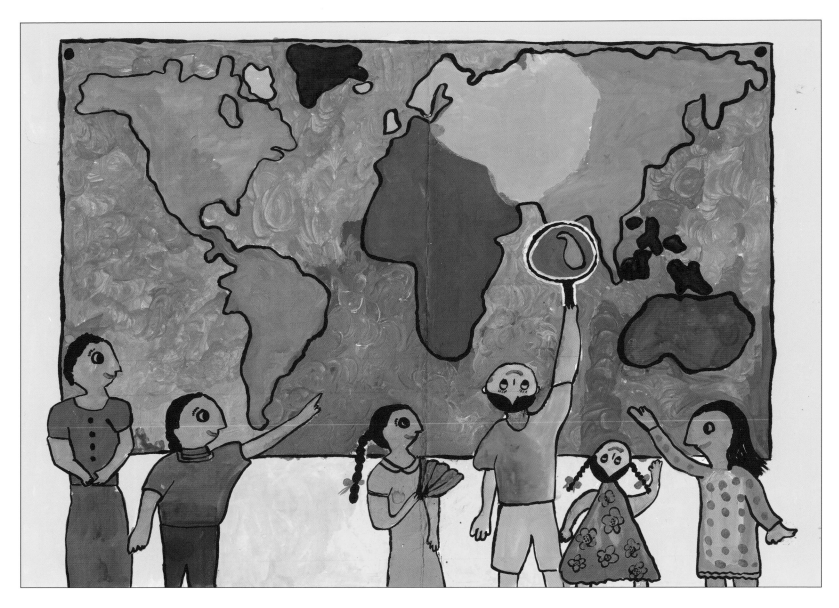

Untitled

Vojitha Heshan Herat

8

Sri Lanka

Royal International School

2013

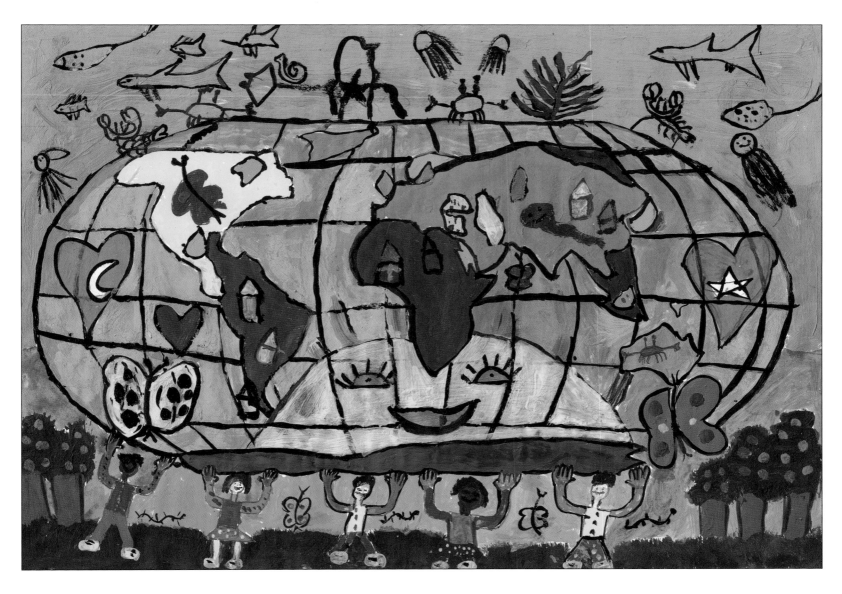

The World of My Dreams
Altuğ Namık Yavaş
8
Turkey
Ahmet Haşim Primary School
2013

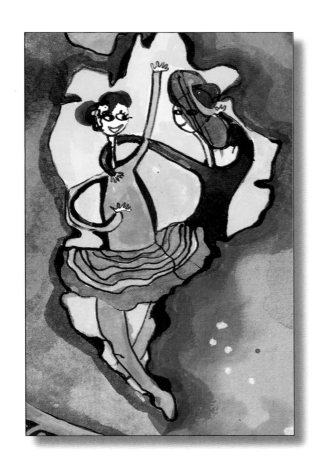

Ages 9 to 12

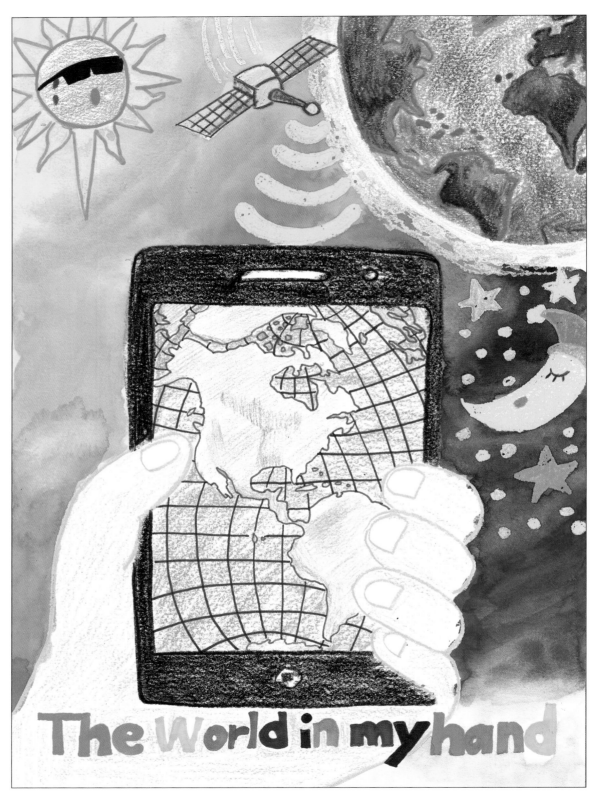

The World in My Hand
Allison Lee
9
Canada
Eagle Heights Public School
2013

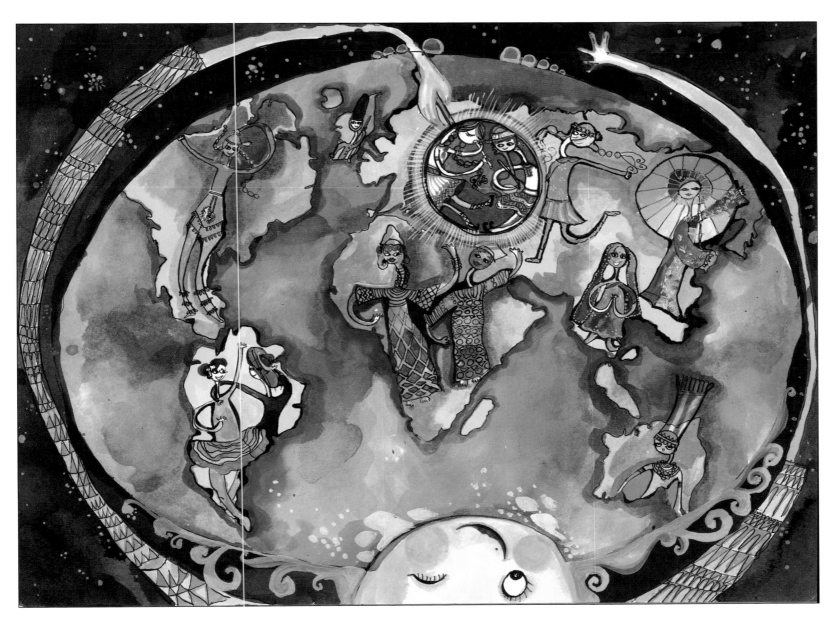

Happy Earth Is Music to Our Ears

Ada Maria Ciontu

9

Romania

Bucharest, Romania

2013

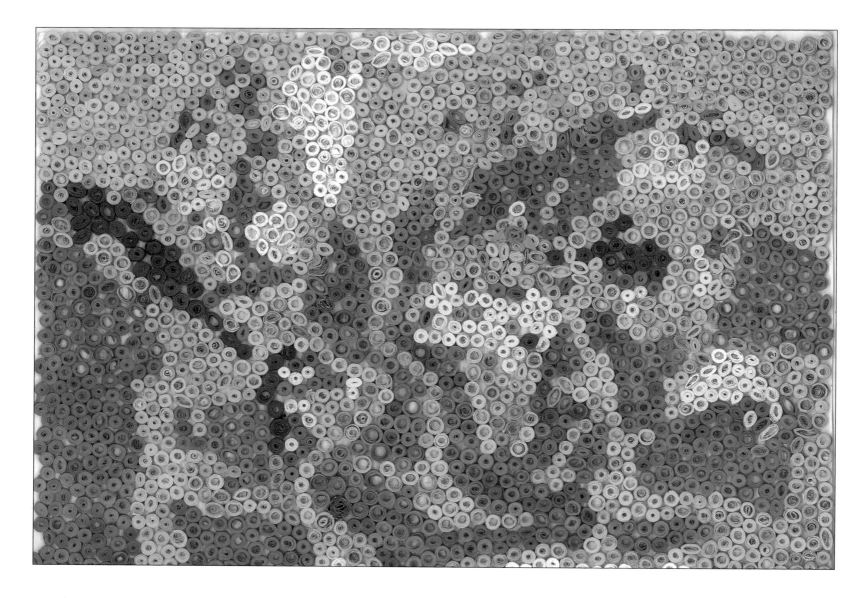

The World Is Beautiful, the World Is Wonderful, the World Needs My Song

Tsvetomira Atanasova Tsvetanova

10

Bulgaria

Peyo Yavorov School

2013

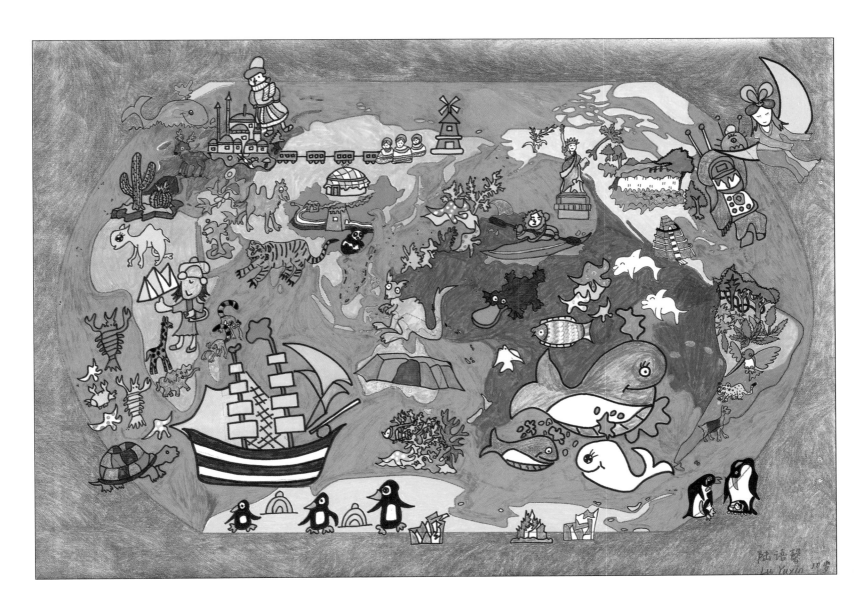

Wonderful World

Lu Yuxin

10

China

Wenyi Street Primary School

2013

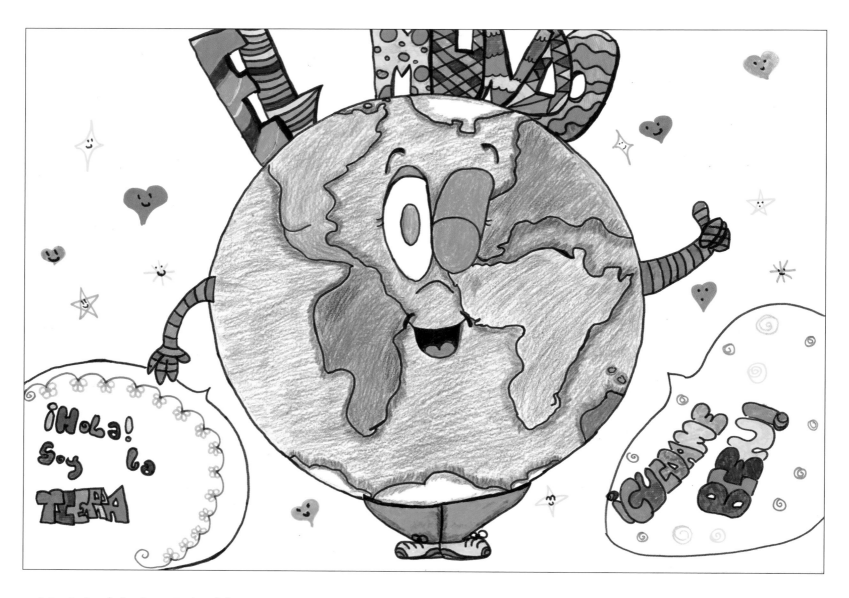

My World, Our World

Paula Sanchez Carrasco

10

Spain

C.P. Lope de Rueda

2013

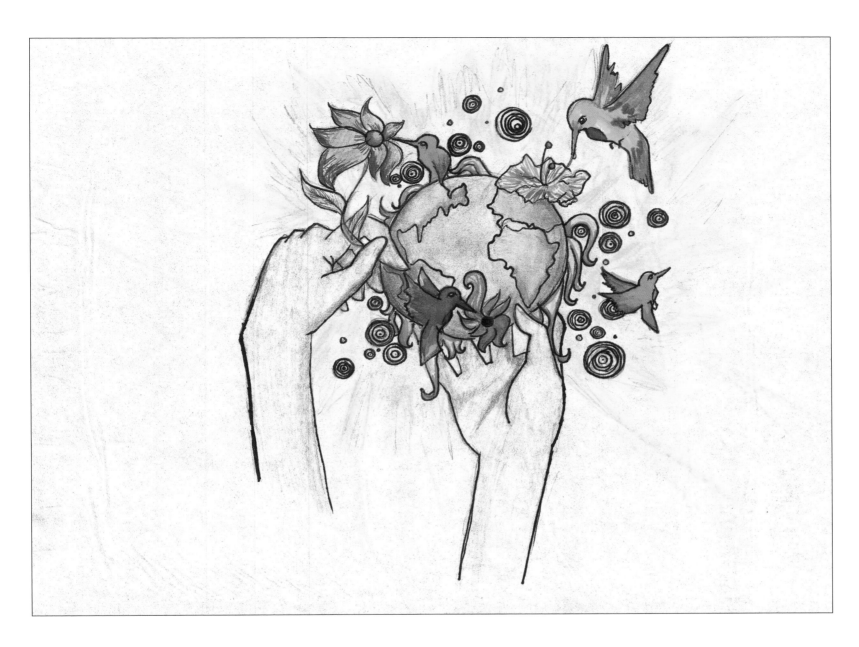

Remembering the World's Beauty
Azea Oliva
10
United States
Grijalva Elementary School
2013

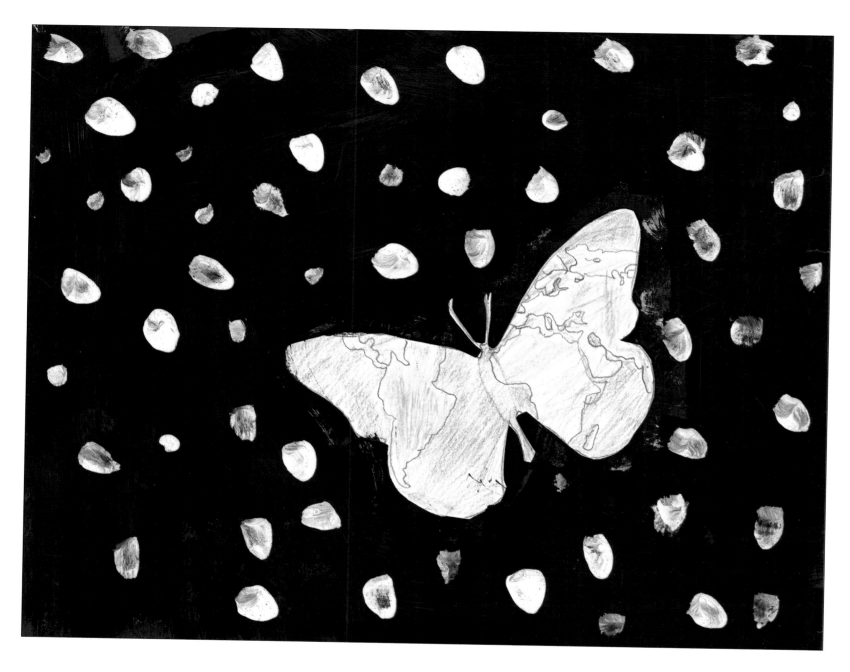

The Flying World

Silje Merethe Moe Sivertsen

11

Norway

Vanvikan skole

2013

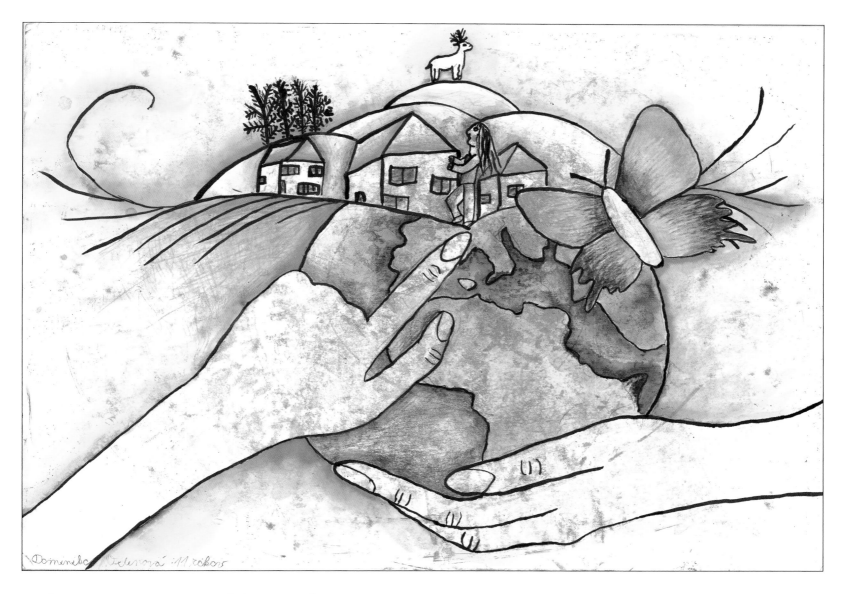

There Is My Piece of the Earth
Dominika Vilinová
11
Slovakia
Základná umelecká škola J. Melkoviča
2013

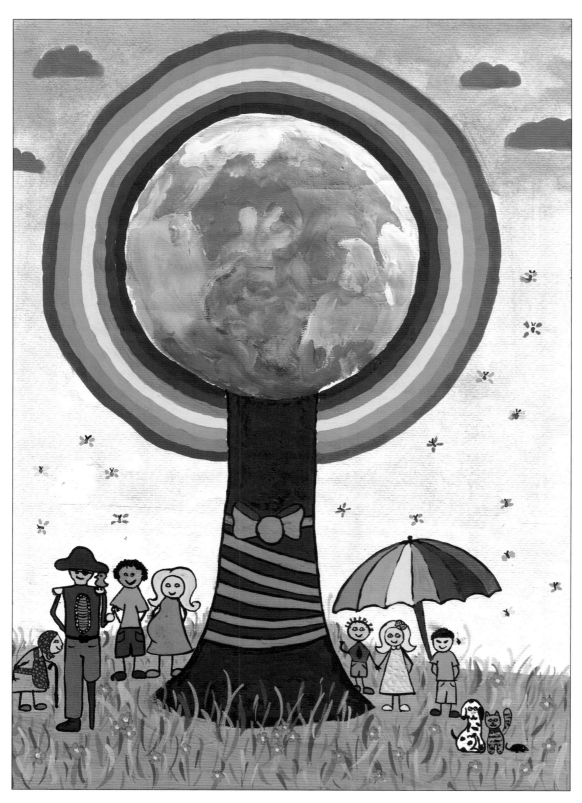

Planet Earth's Rainbow World

Lana Savič

11

Slovenia

OŠ Ketteja in Murna

2013

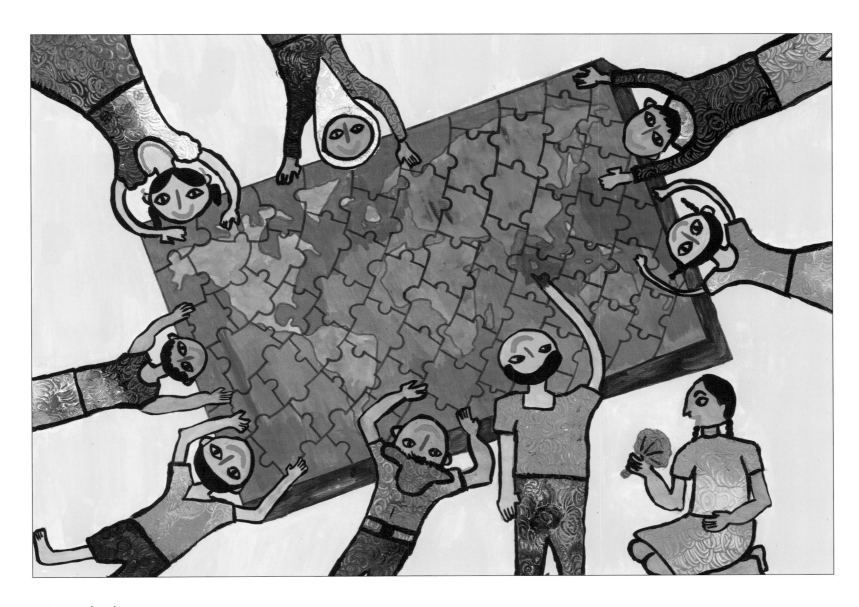

Untitled
Savindu Hiranniya Herat
11
Sri Lanka
Royal International School
2013

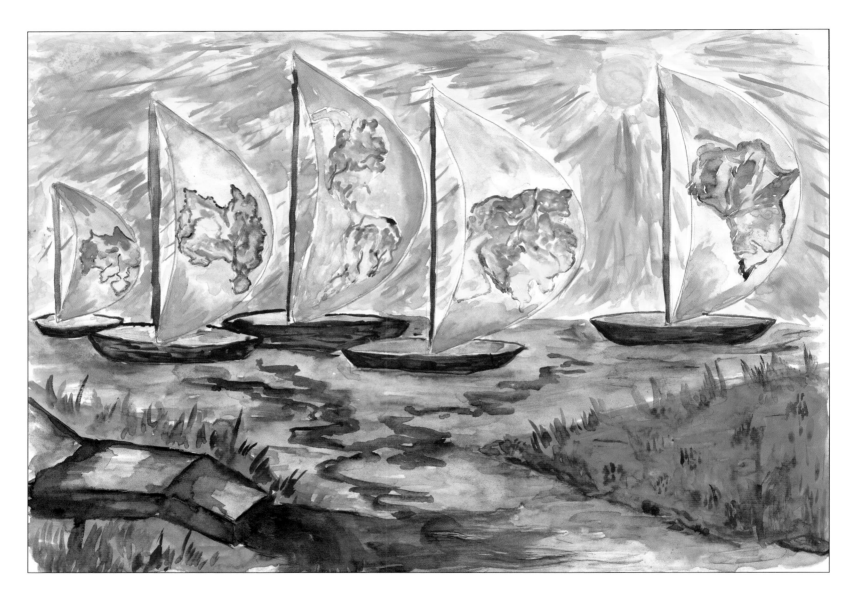

Sails of Hope
Tetiana Morozova
11
Ukraine
Secondary School #37
2013

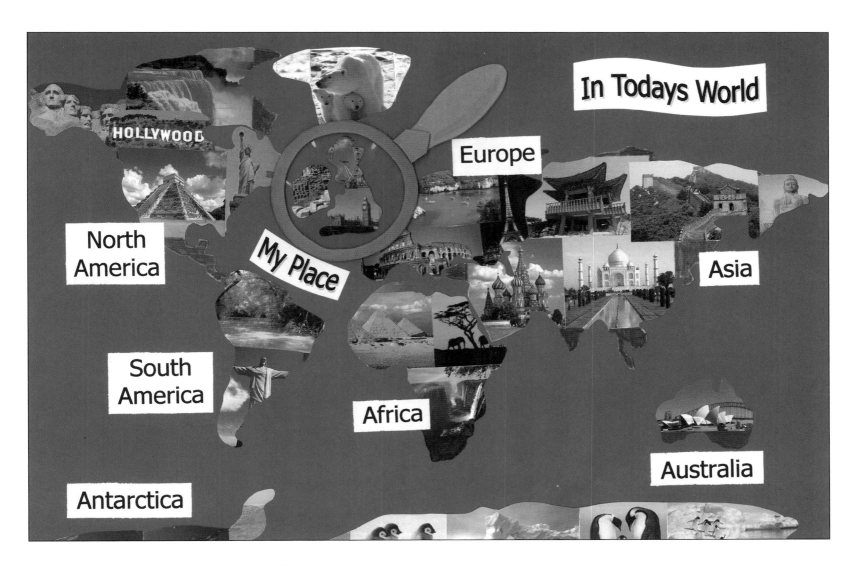

My Place in Today's World
Devon Bennett
11
United Kingdom
Court Moor School
2013

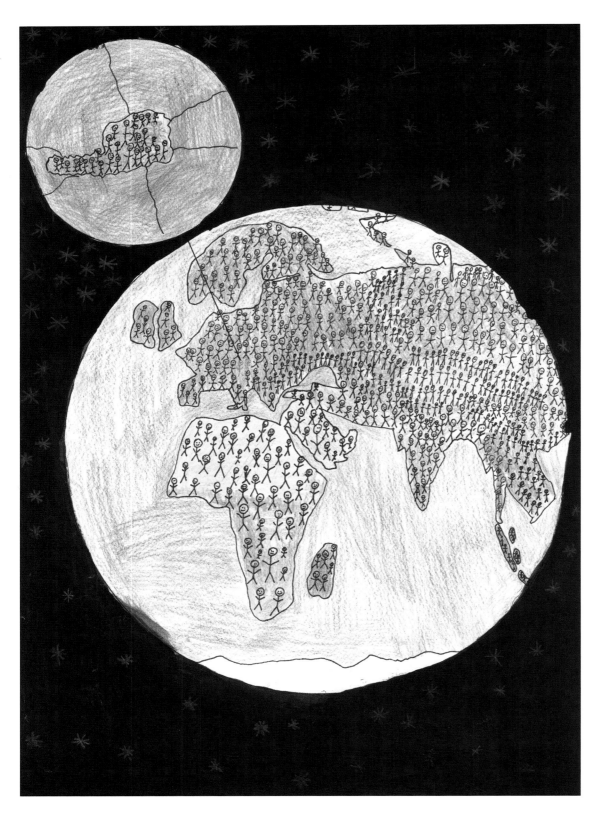

One Among Many
Florian Gruber and Lukas Schostal
12
Austria
Polgargymnasium Wien 22
2013

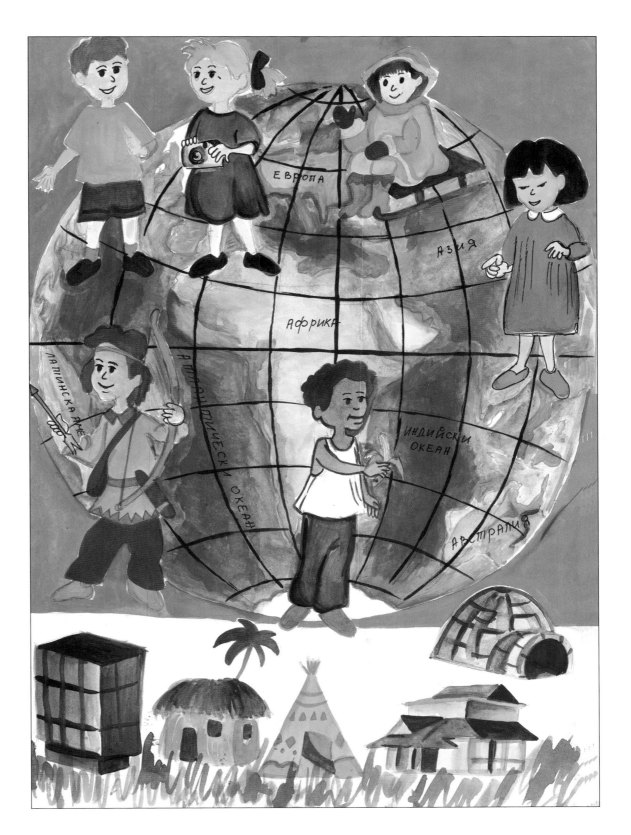

We Live in Different
Places, but We Have
the Same Dreams
about the World
Natalia Kazieva
12
Bulgaria
Art School Zhivopis
2013

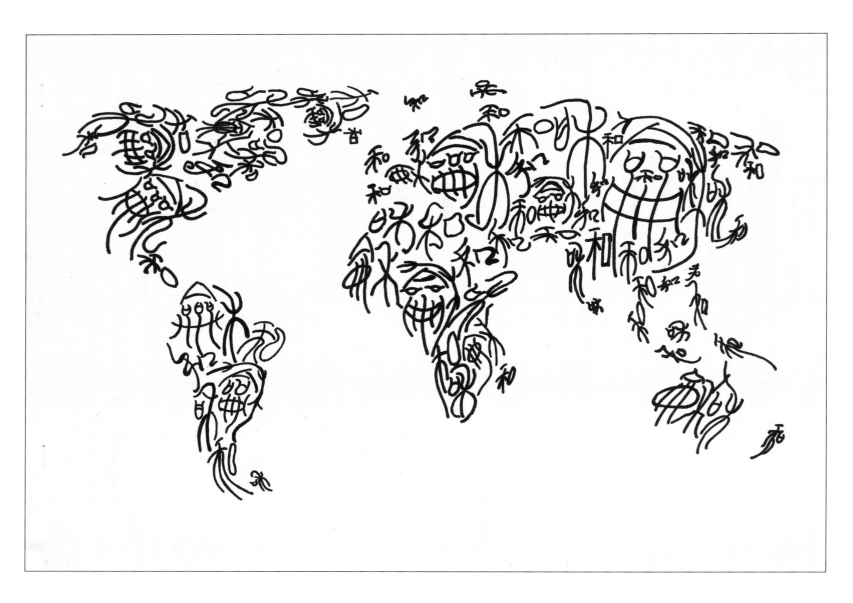

Peace & Harmony
Wang Zhiling
12
China
No. 3 Primary School of Hangkonggang District
2013

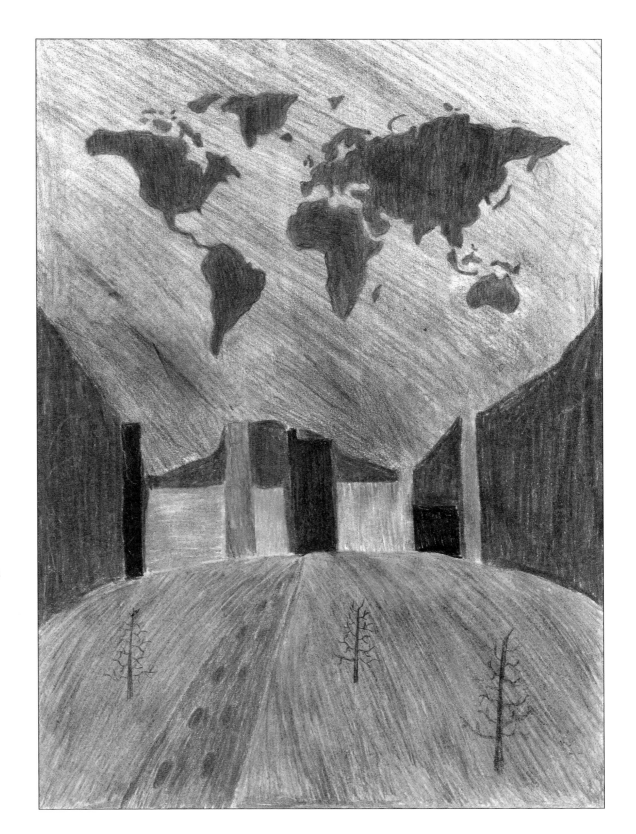

Our Choices Form the World
Anni Luukkonen, Rea Laakso,
and Oona Nieminen
12
Finland
Hyökkälän koulu
2013

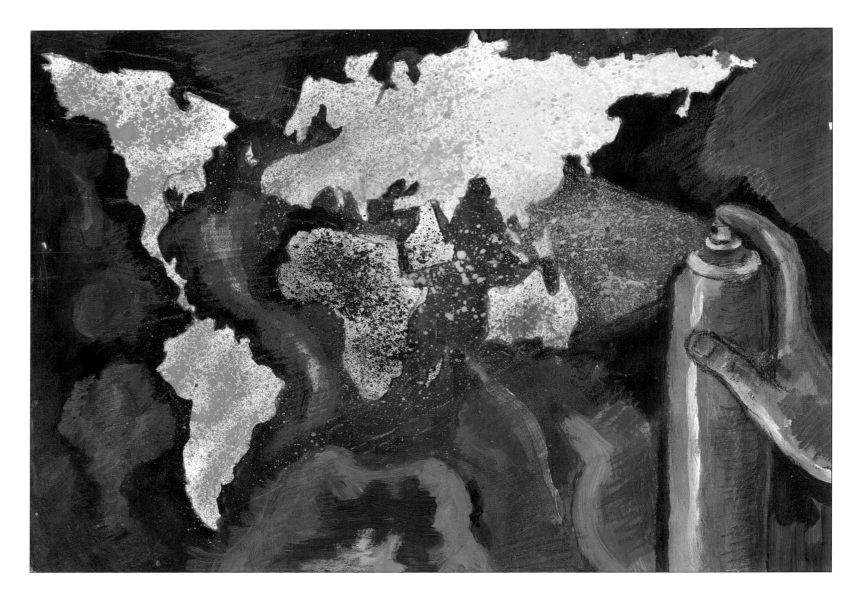

I Want to Be a World Famous Graffiti Writer
Filip Líška
12
Slovakia
Súkromná základná umelecká škola
2013

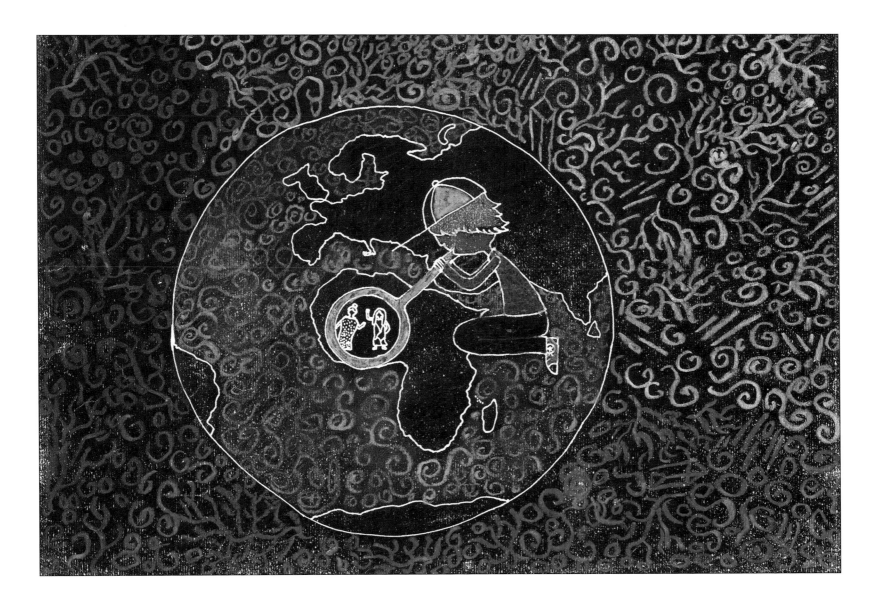

Untitled
Hana Klincov
12
Slovenia
OŠ Koroška Bela
2013

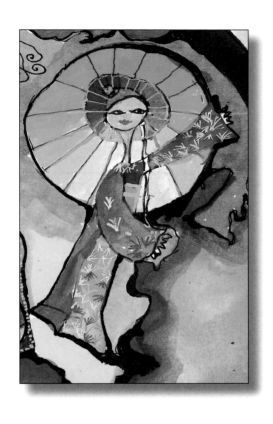

Ages 13 to 15

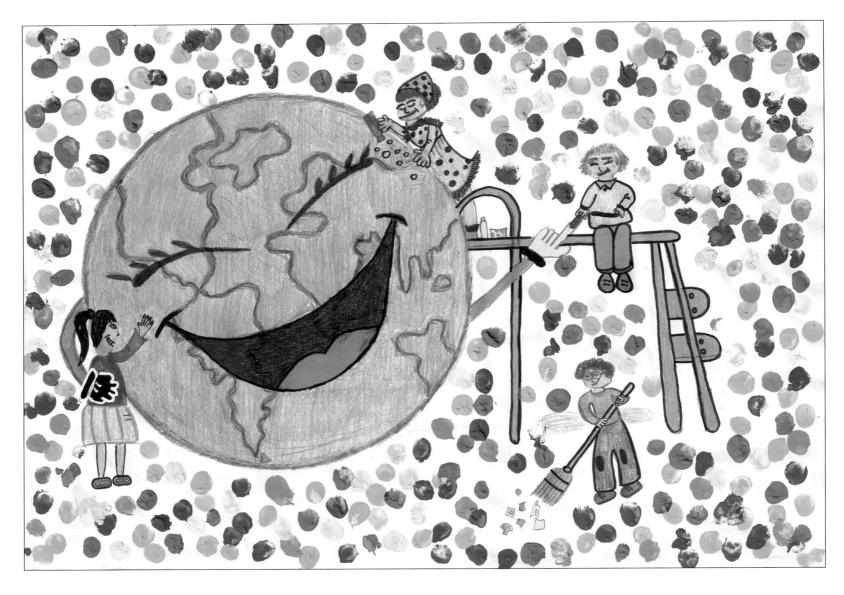

Let's Help Our World and Let's Put Color on It
Florencia Lourdes Crespi
13
Argentina
Instituto San José de Flores
2013

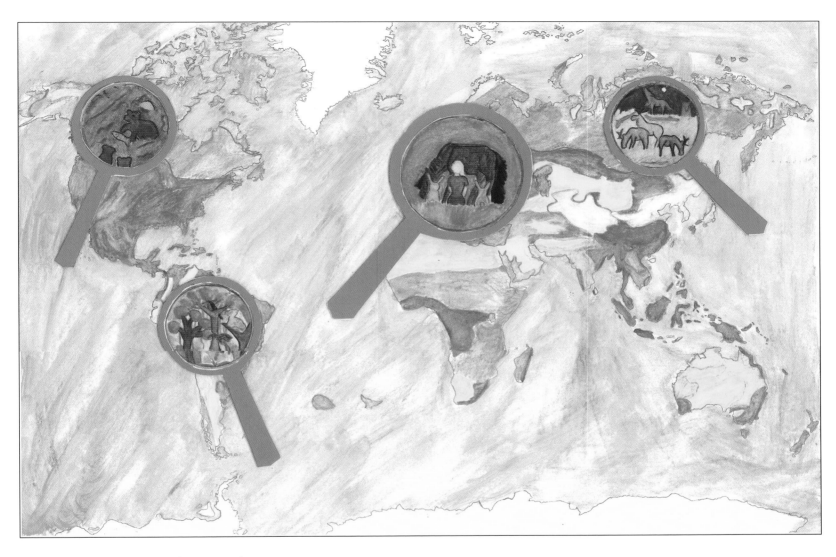

Under the Magnifying Glass

Silja Daim

13

Austria

Bundesrealgymnasium Wien XIX

2013

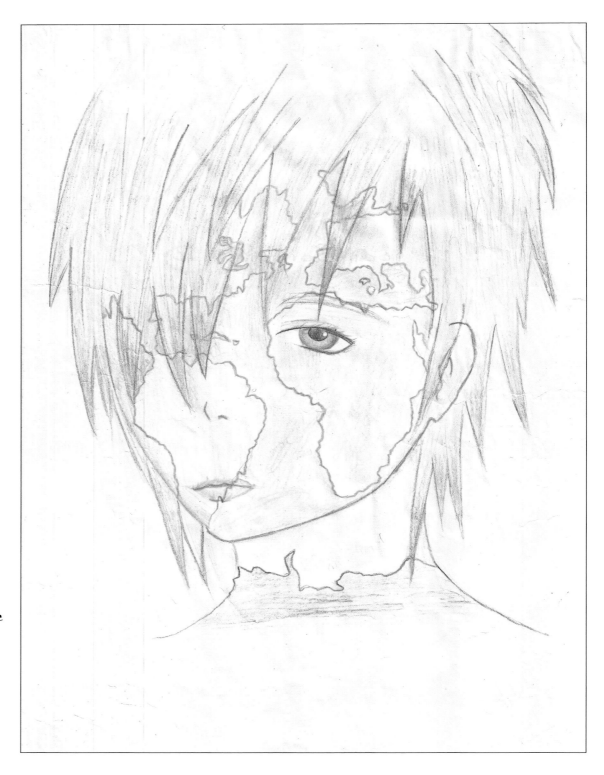

The World in My Face

Beatriz Froehner

13

Brazil

E.M.E.B. Selma Teixeira Graboski

2013

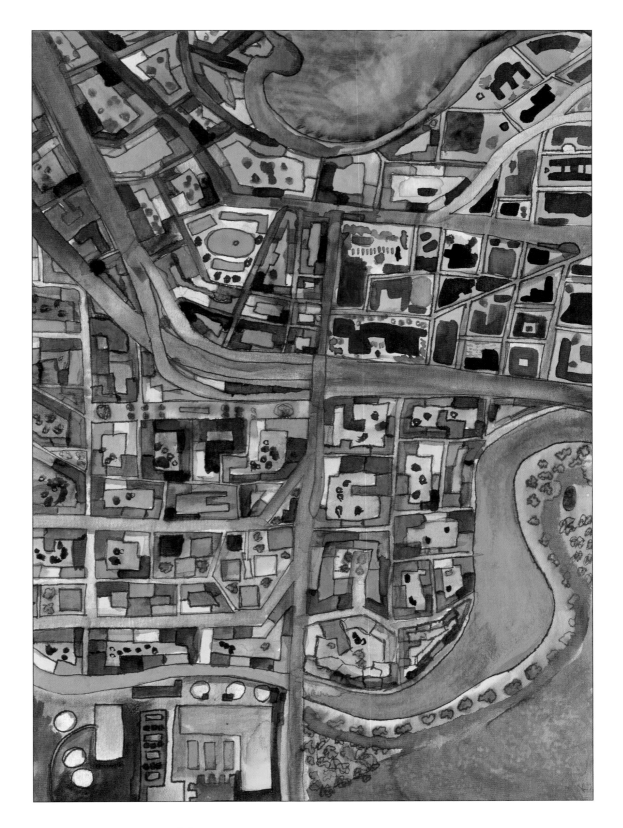

Laxys City
Kateřina Souralová
13
Czech Republic
Gymnázium P. Křížkovského
2013

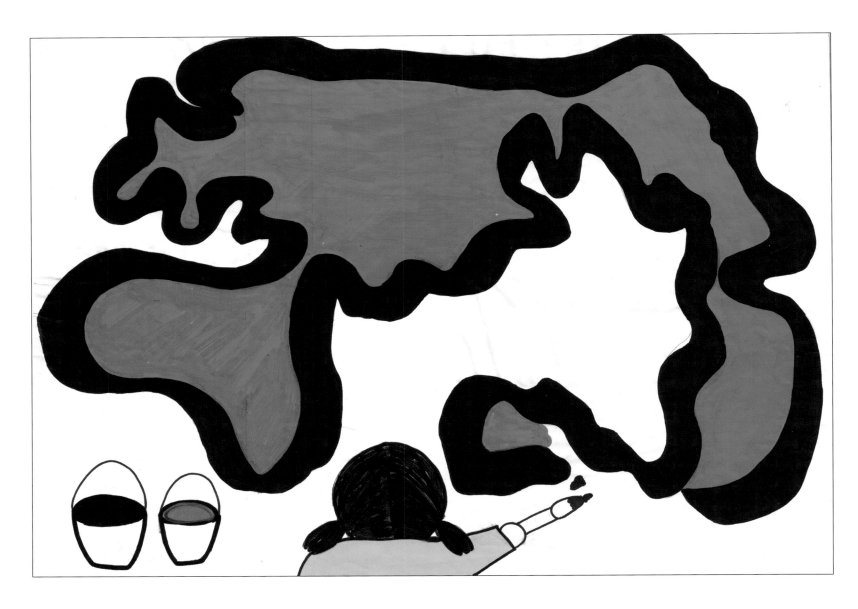

To the One World
Hazuki Ota
13
Japan
Sanyo Girl's Junior High School
2013

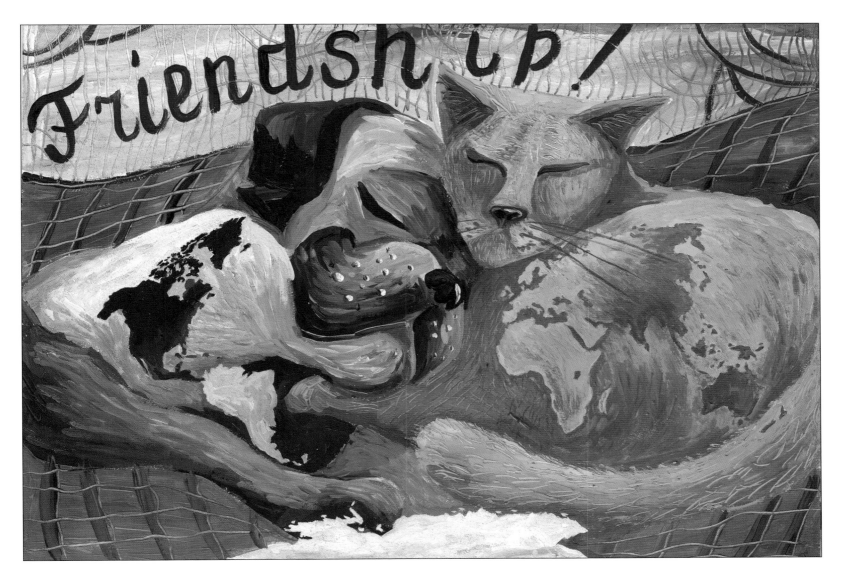

Friendship

Greta Aželytė

13

Lithuania

Utenos Krašuonos progimnazija

2013

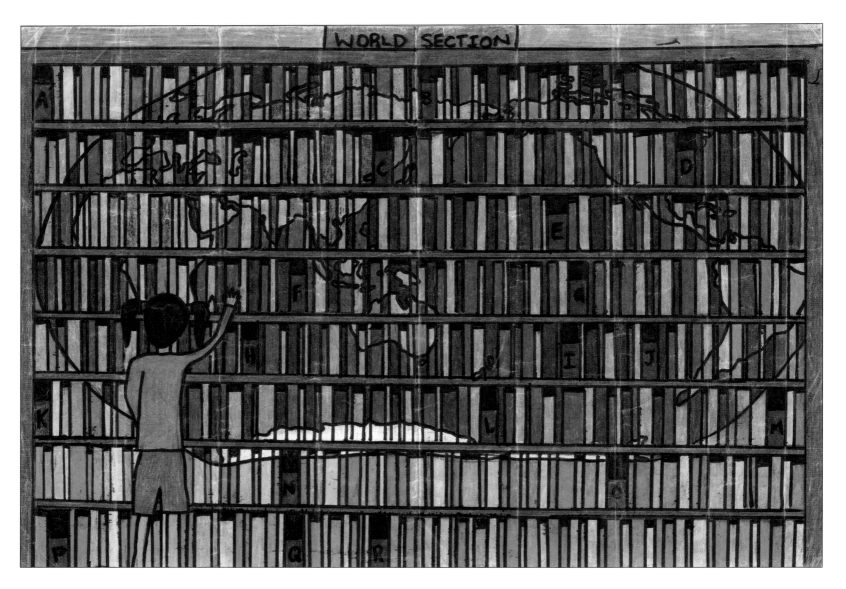

World Section

Amy Wang

13

New Zealand

Te Kauwhata College

2013

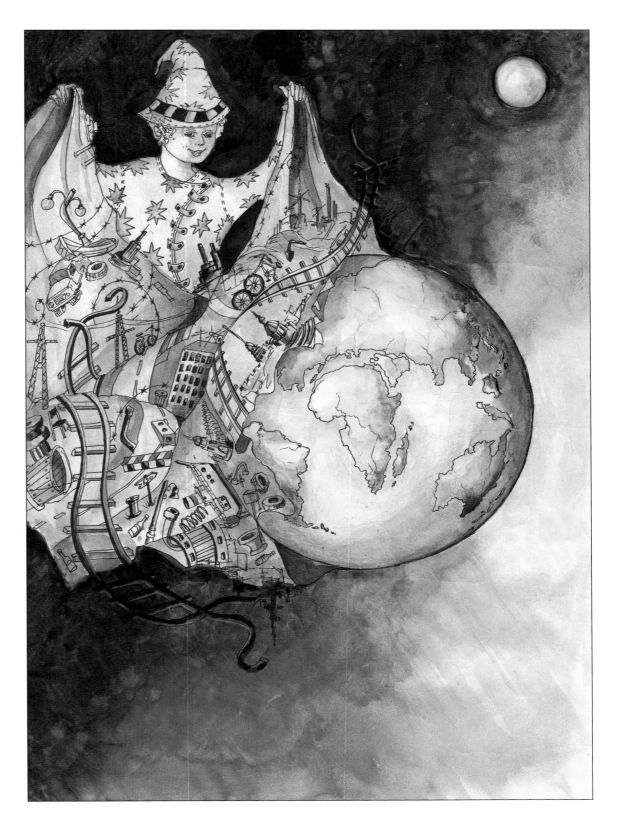

Big Miracle by Little Hands

Karina Balitskaya
13
Russian Federation
School no. 2
2013

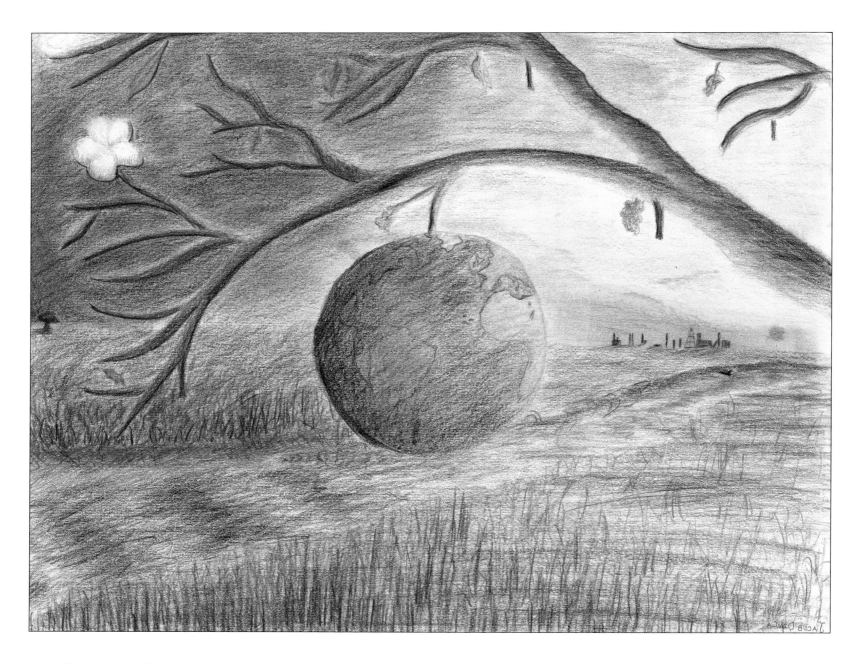

Allegory of Time

Jacob Dimla

14

Canada

London, Ontario, Canada

2013

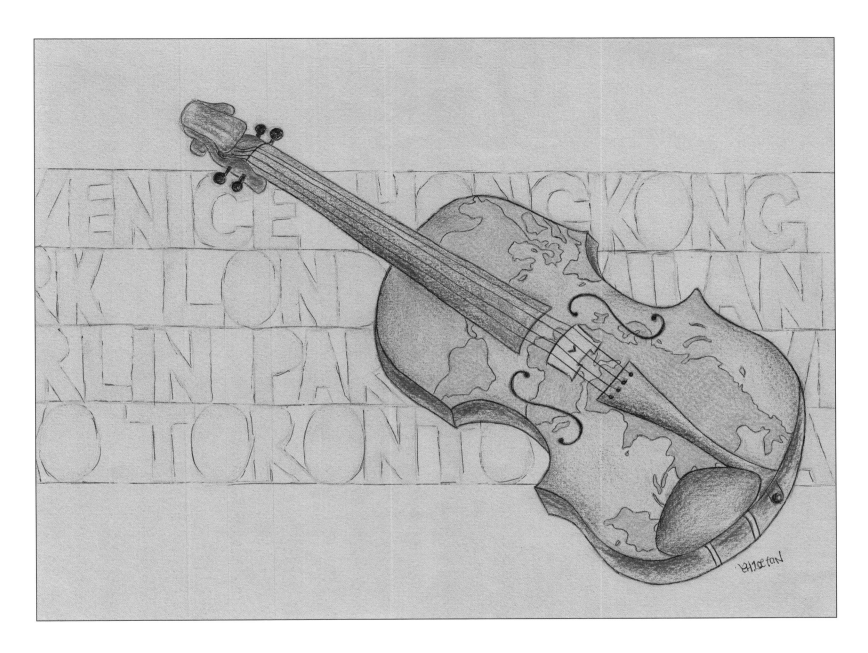

Untitled

Chloe Fan
14
Canada
Unionville, Ontario, Canada
2013

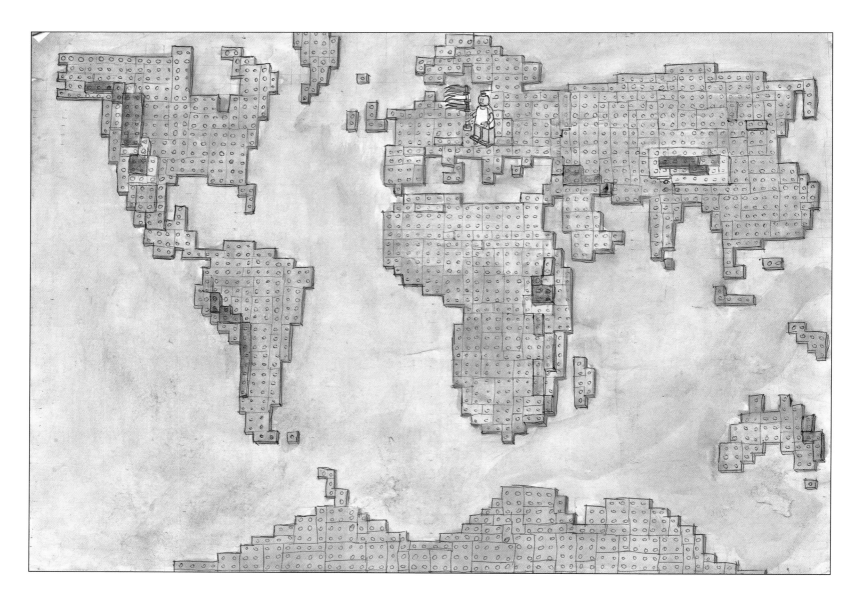

Even Today Building the Earth in This Way

Bence Gerliczky

14

Hungary

Fazekas Mihály Elementary and Secondary School

2013

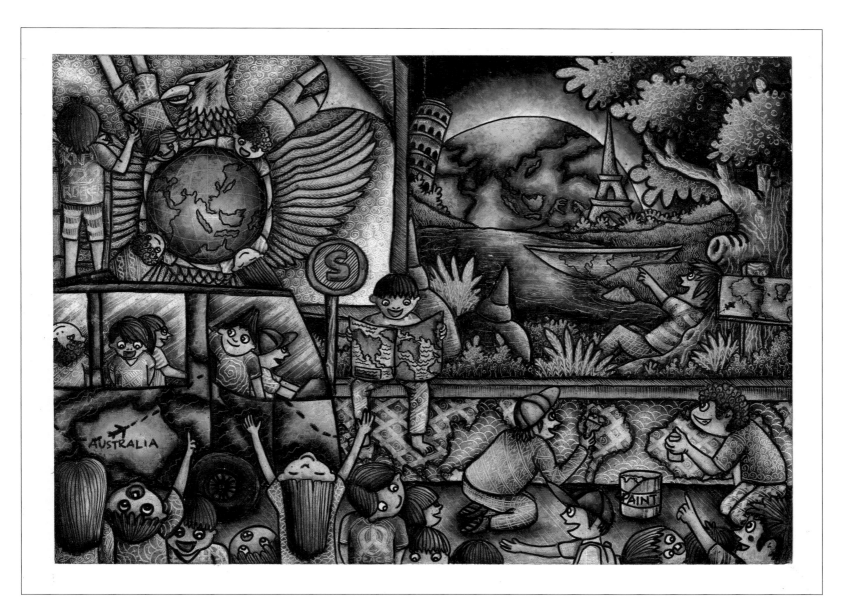

I Watch the World

Anang Makruf

14

Indonesia

SMPN 3 Salaman

2013

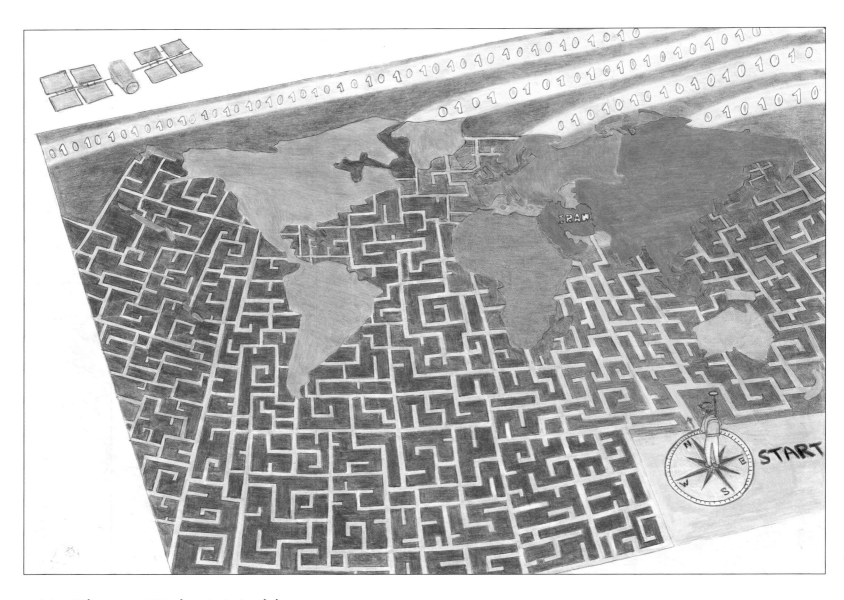

My Place in Today's World

Mostafa Mezahi

14

Iran

Tehran, Iran

2013

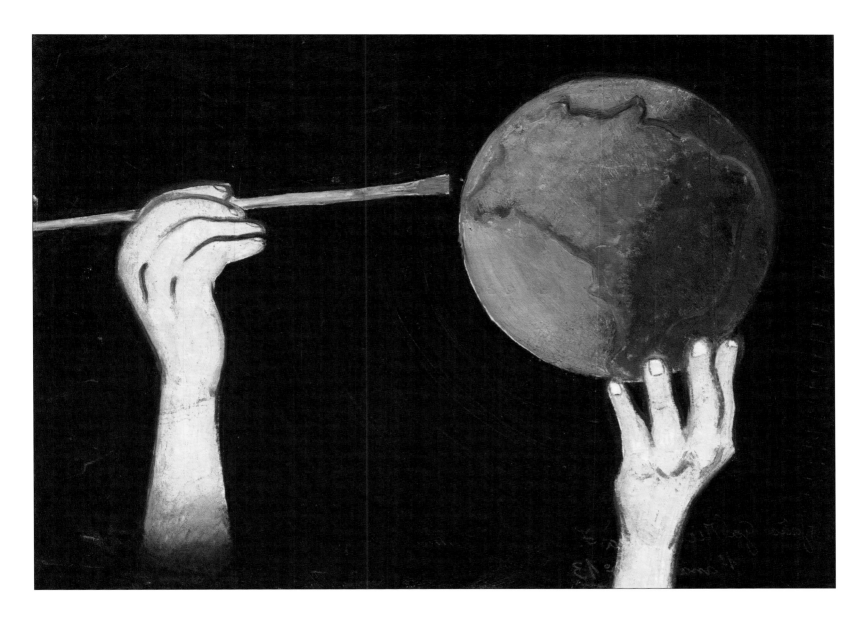

After Darkness

Joao Gabriel Terra Ferreira

15

Brazil

Centro Educacional - SESI 124

2013

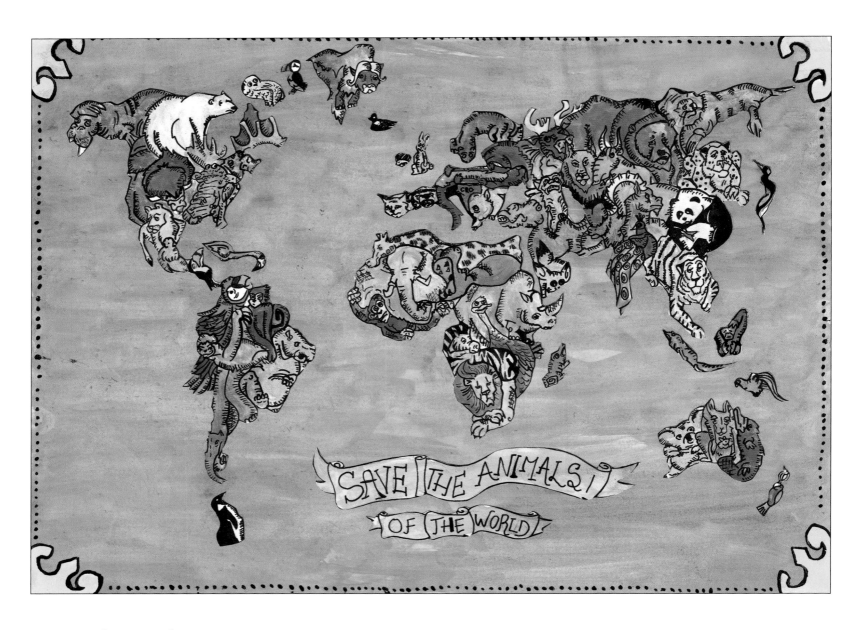

Save the Earth's Beauty
Vladimir Prodanović
15
Croatia
Škola primijenjene umjetnosti i dizajna Osijek
2013

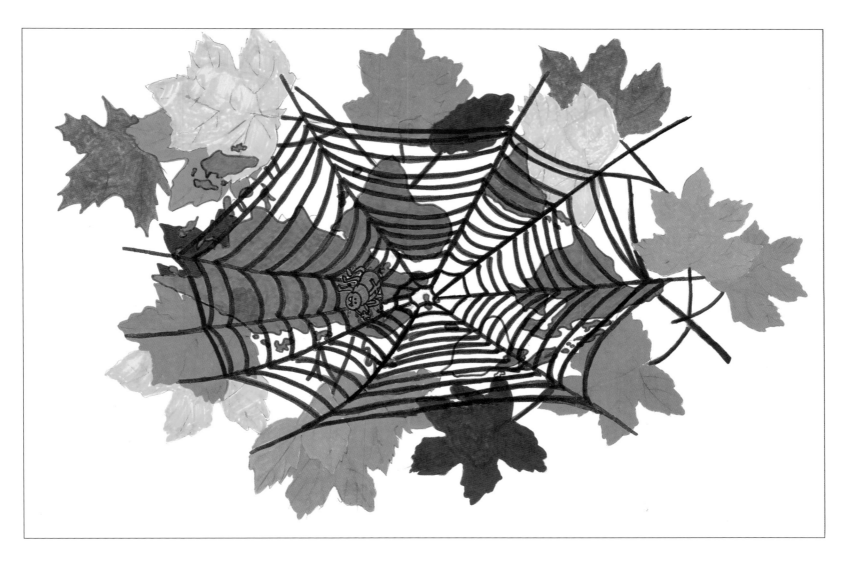

Autumn World View
Laura Kozma
15
Hungary
Eötvös József Lutheran High School and Medical Vocational School
2013

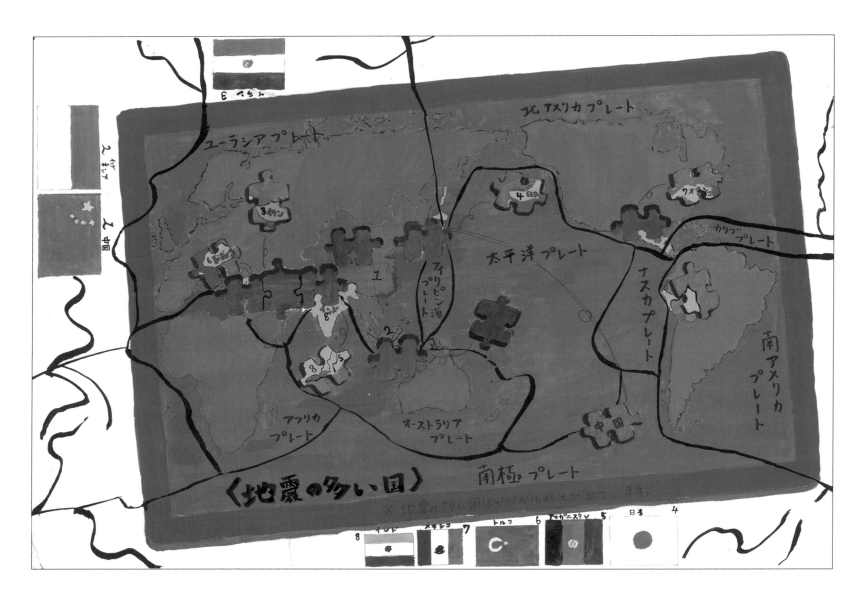

Countries with a Lot of Quakes

Wakana Yamamoto

15

Japan

Higashimurayama 5th Junior High School

2013

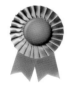

Be Careful
Alla Sukhanova
15
Russian Federation
Children's Architectural Art Studio
PROUN
2013

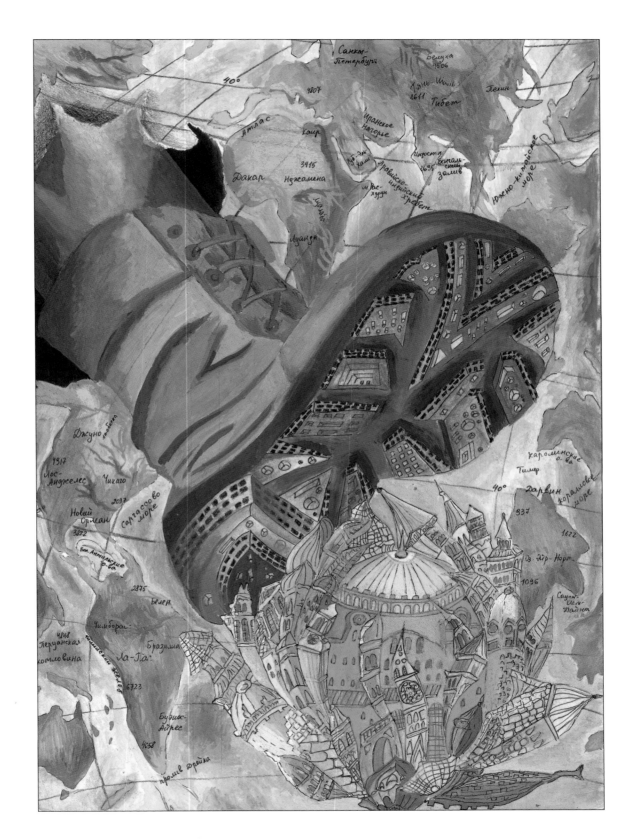

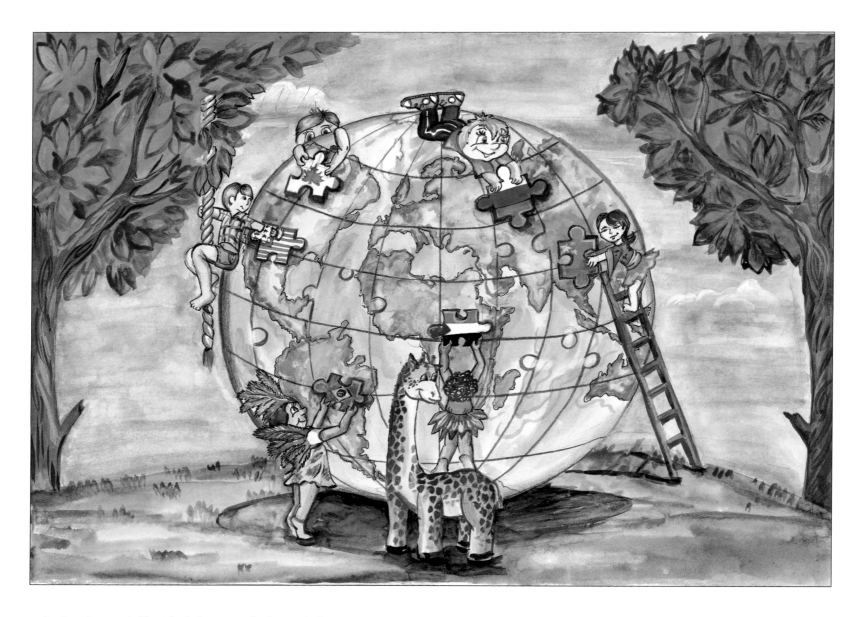

We Are All Children of One Planet

Anna Bolshakova

15

Russian Federation

Navashino Marine Engineering College

2013

Me in Nature
Shane Langley
15
South Africa
Die Hoërskool Menlopark
2013

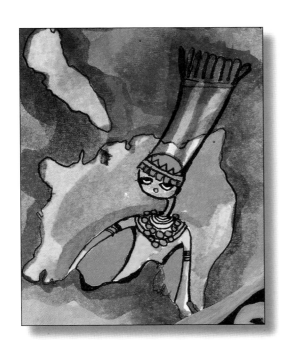

Entries from
1993 to 2011

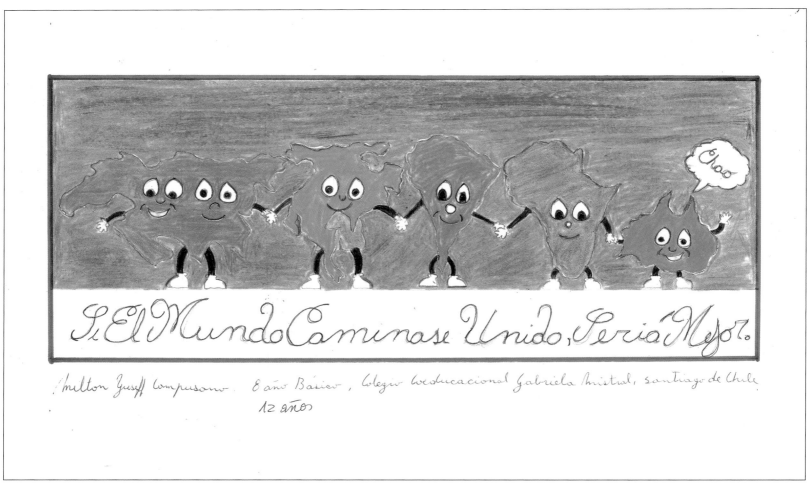

If the World Were Walking Together, It Would Be Better for Us

Milton Yussef Campusano

12

Chile

Colegio Educational Gabriela Mistral, Santiago de Chile

1993

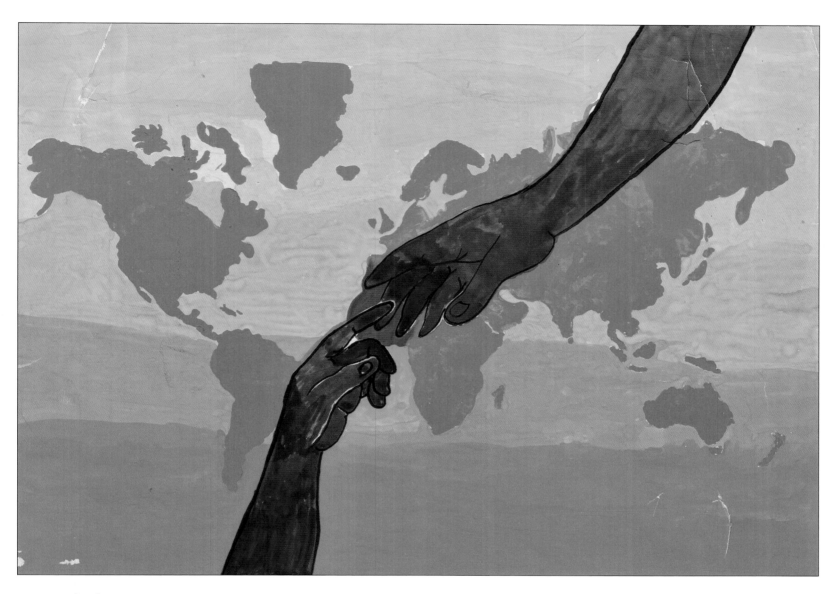

Untitled
Dhammika Sisira Kumara
15
Sri Lanka
Subodrarama Maha Vidyalaya. Gangodawila, Nugegeoda
1993

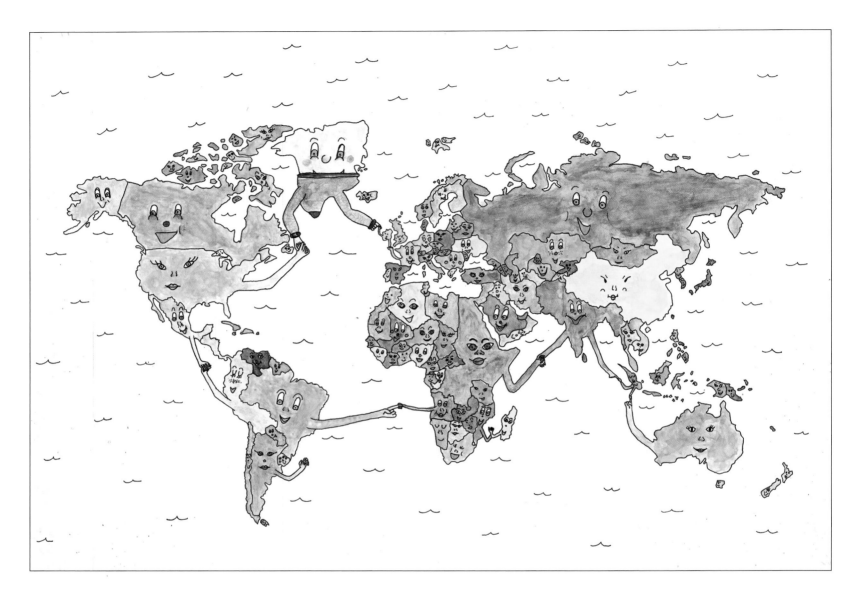

Untitled

Marie-Christine Planques

11

France

Institut Montalembert, Nogent-sur-Marne cedex

1995

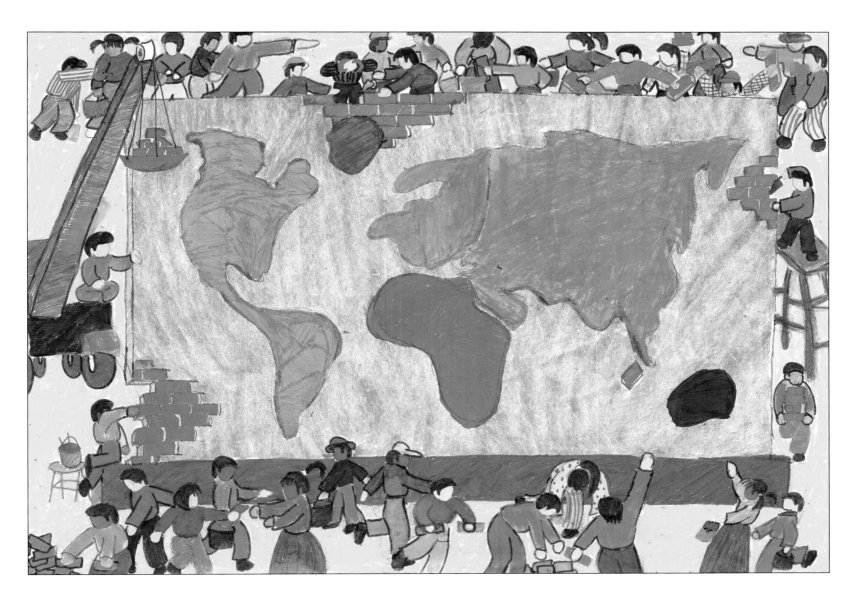

Guard Our Earth
Nguyen Duc Khanh
14
Vietnam
Cultural House of Children of Hai Hung Province
1995

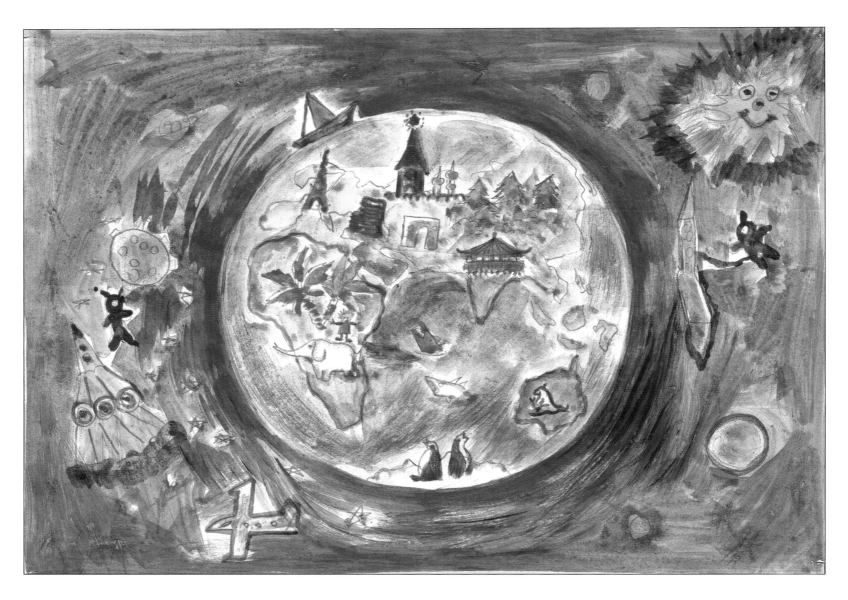

Earth
Mustafaev Beibud Vagif oghli
8
Azerbaijan
1997

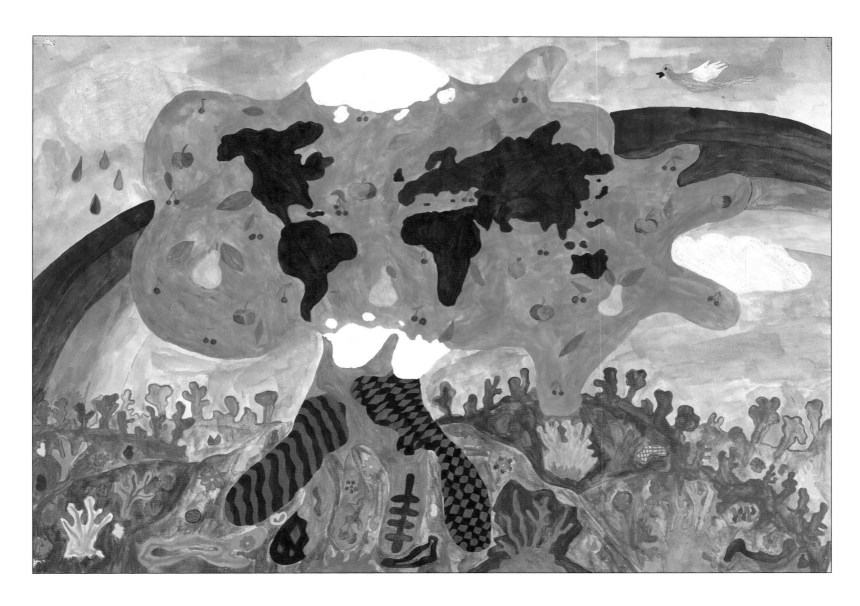

The World Tree
Wanda Hornig
15
Germany
Rosenhofschule, Staatliche Regelschule, Mülhausen
1997

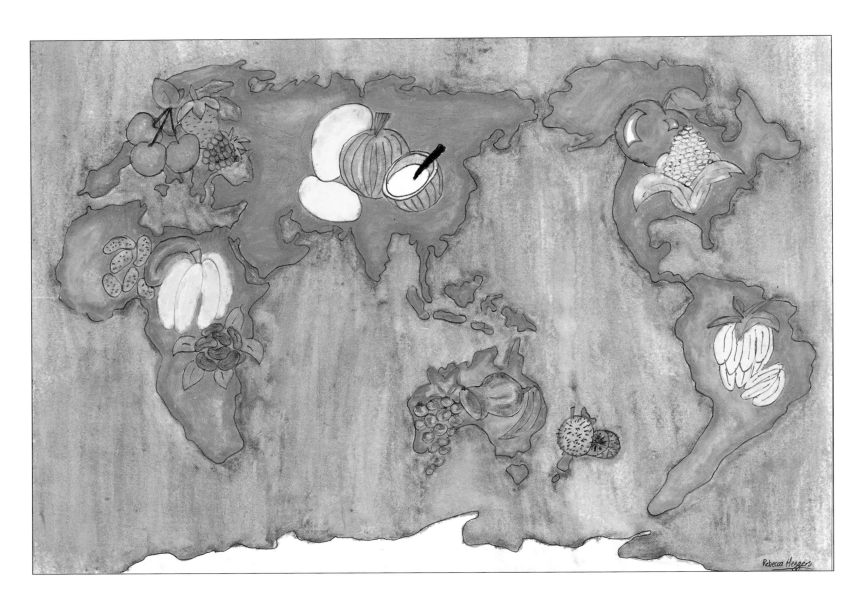

A World of Fruits

Rebecca Heggers

13

Australia

1999

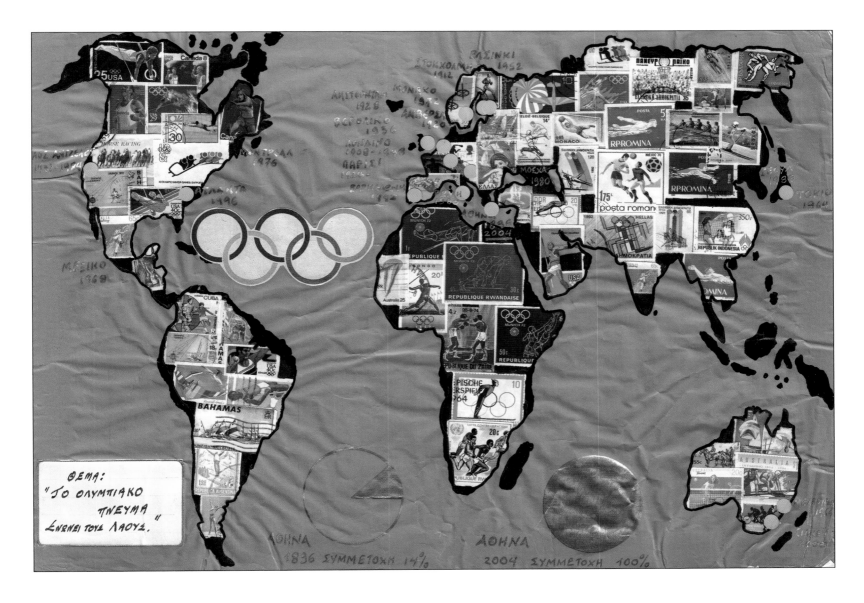

The Olympic Spirit Unites People

Emmanouil Kopanezos

11

Greece

Kalimnos

1999

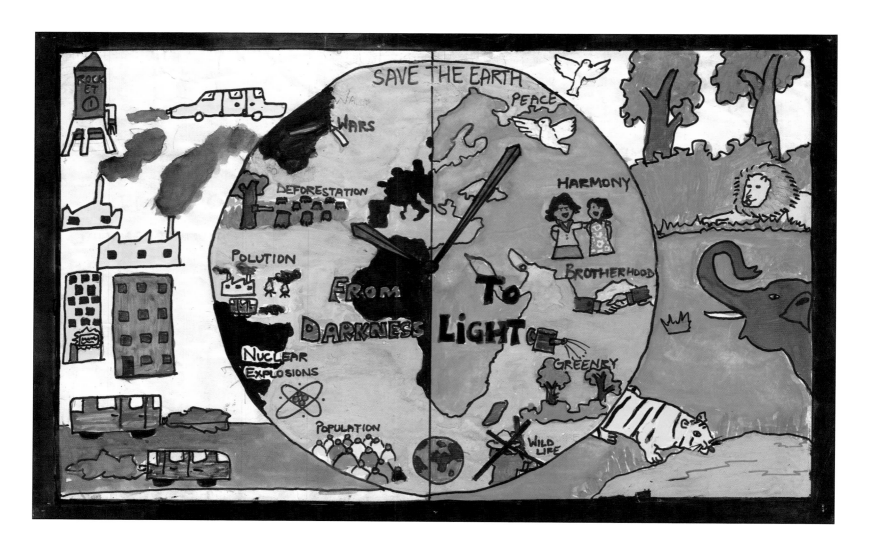

Save the Earth

Radhika Dimri

11

India

Convent of Jesus and Mary, Dehra Dun, Uttaranchal

2001

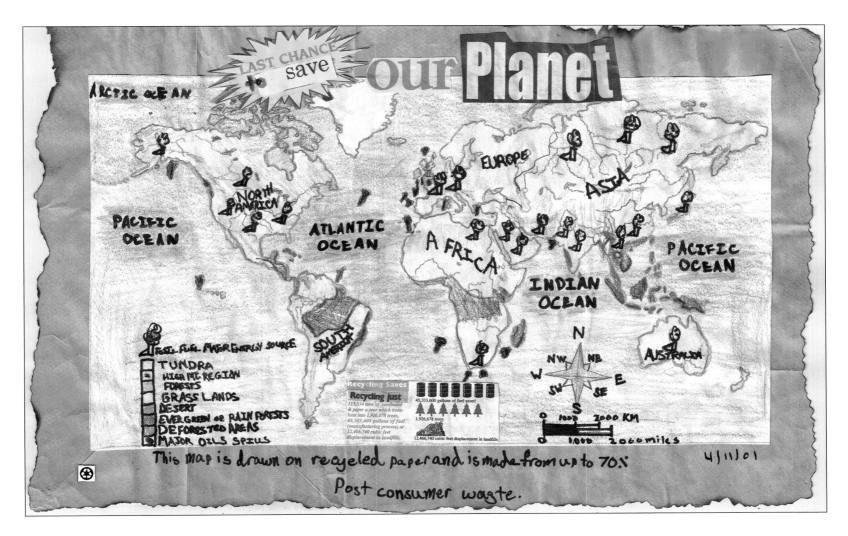

Last Chance to Save Our Planet

Grant Mayer

9

United States

Seward and Elementary School, Kenai Peninsula Borough

2001

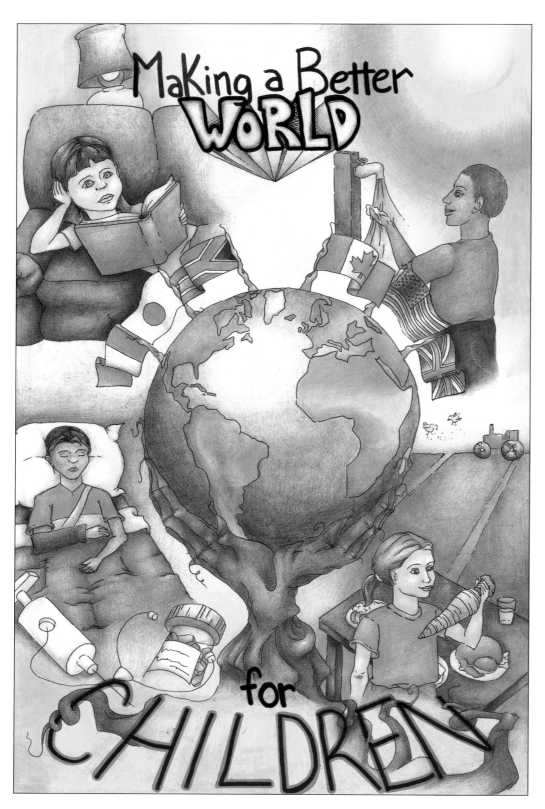

Making a Better World for
Children
Patricia Lan
14
Canada
Glenlyon-Norfolk School, Victoria, BC
2003

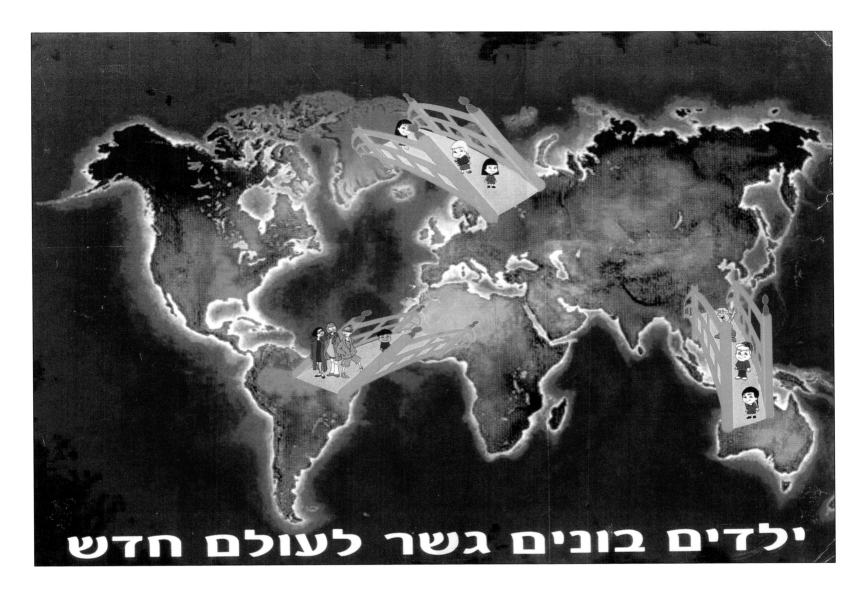

Children are Building Bridges toward a New World
Mor Arbel
13
Israel
Amiasaf School
2003

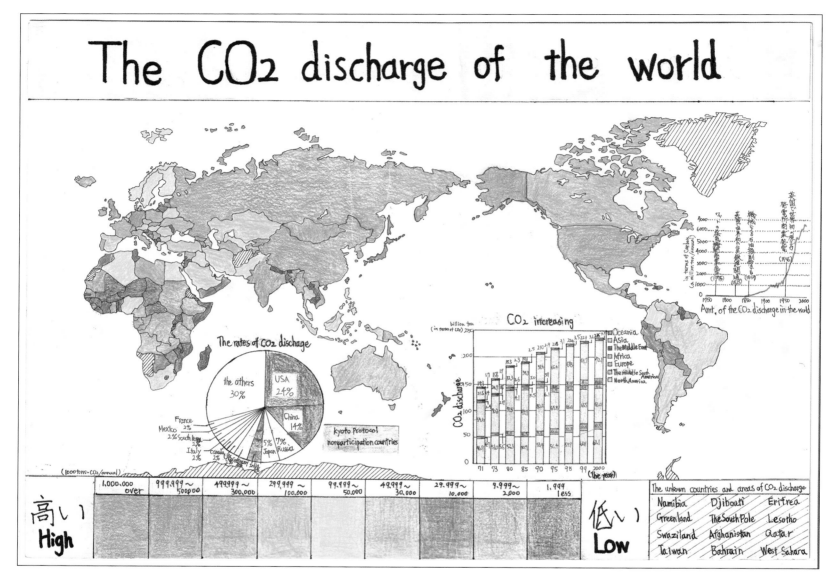

The CO₂ discharge of the world

The Total CO₂ Discharge

Baba Mobuaki

15

Japan

Matsue 1st Junior High School, Tokyo

2005

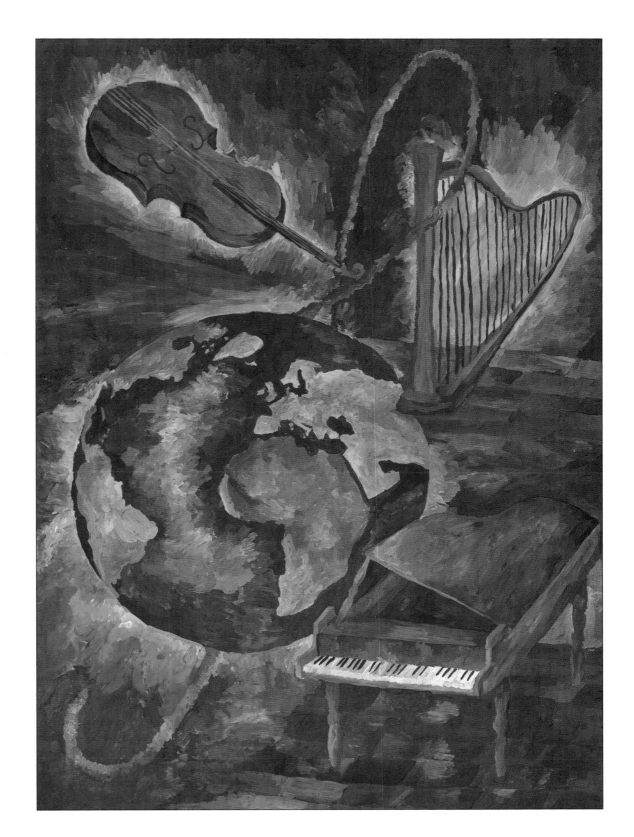

Music around Our World
Annamária Ferencz
12
Romania
School of Arts, Târgu Mureş
(Marosvásárhely)
2005

The World Looks Like a Ball of Wool

Agustina Yanetti Torres

11

Argentina

2007

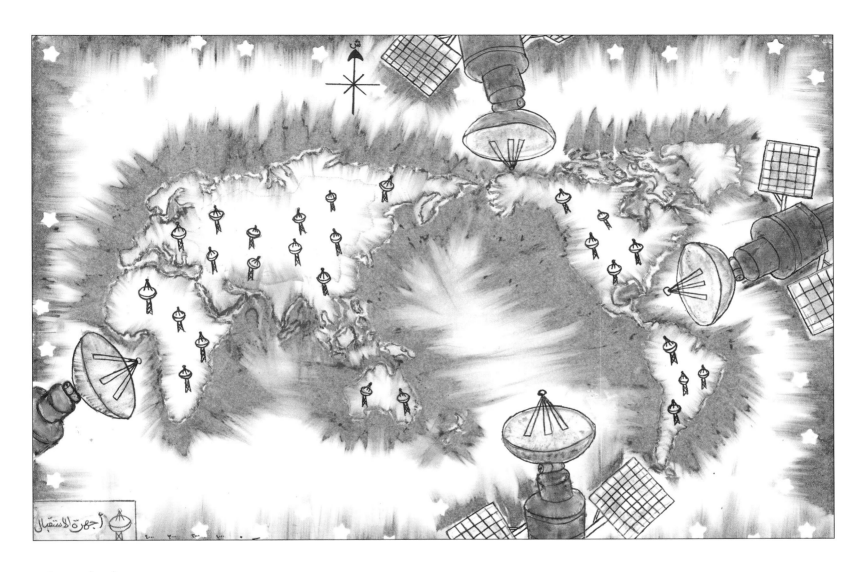

Untitled

Eman Owaz Abd-Alalem

14

United Arab Emirates

Alkarama School, Abu Dhabi

2007

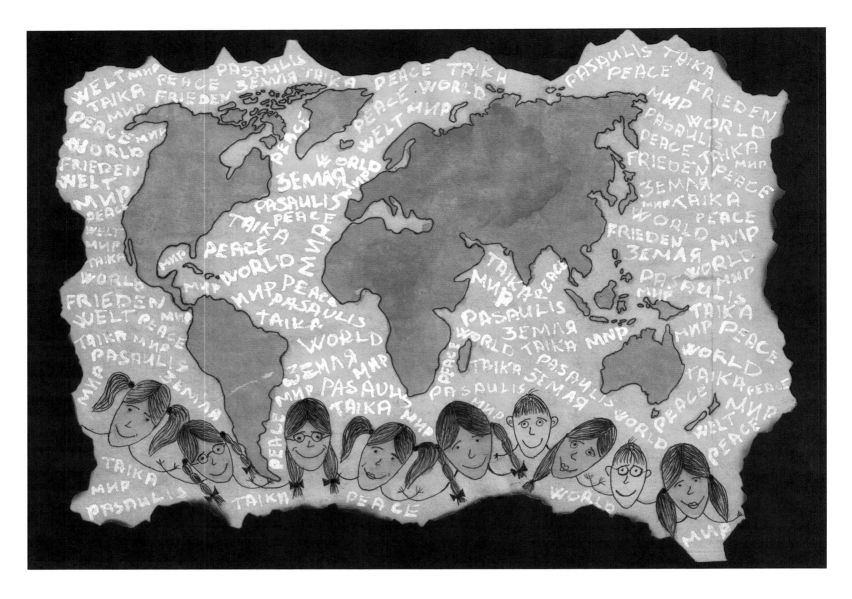

The Old Map

Indrė Stakvilevičiūtė

14

Lithuania

Radviliškis Vaižgantas Main School, Radviliškis

2009

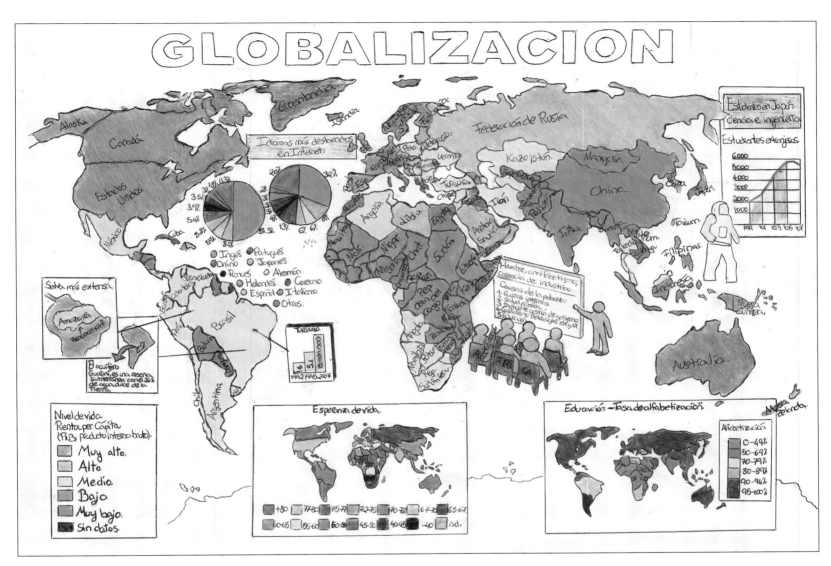

Globalized World

Beatriz Borroso Gstrein

12

Spain

Colegio San José, Estepona

2009

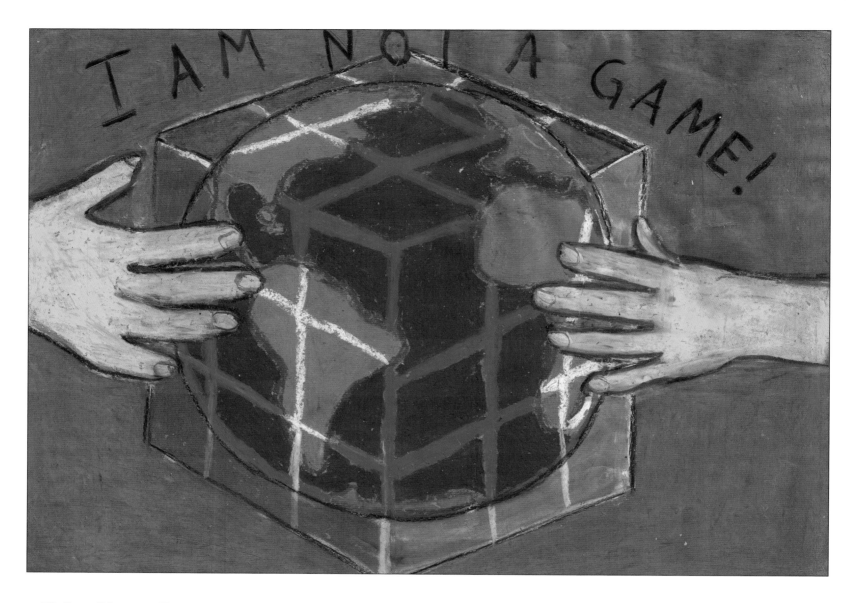

I Am Not a Game
Filio Kyriacou, Valanto Gavriel, Vasiliki Papa, and Evgenia Papapanaretou
10
Cyprus
Elementary School of Kornos, Kornos
2011

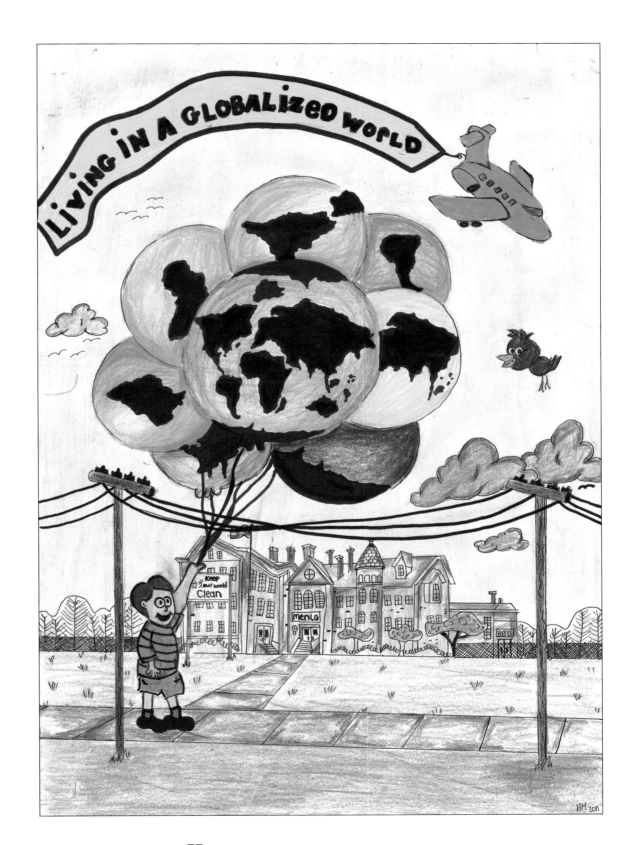

Boy with the Balloons
Helene-Marie Guillaume
14
South Africa
Die Hoerskool Menlopark, Gauteng
2011

Conversations with map makers

The editors contacted participants in the Barbara Petchenik Children's World Map Competition
and asked them to share their competition experiences and thoughts about their work.

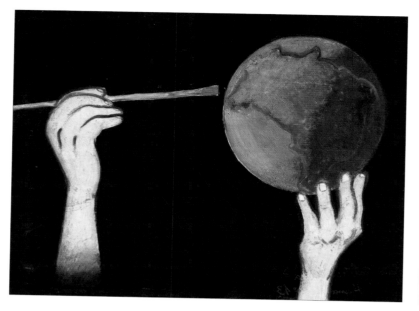

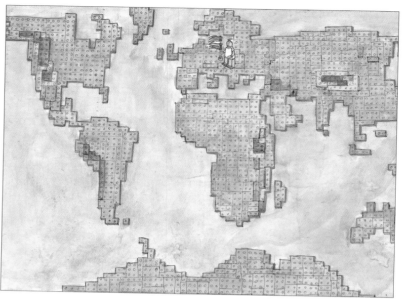

João Gabriel Terra Ferreira, 15
Brazil
2013
After Darkness

Bence Gerliczky, 14
Hungary
2013
Even Today Building the Earth in This Way

What motivated you to enter the competition?

The will to really do something different, which I could highlight through illustrations while still maintaining relations with design patterns from other parts of the world.

Which message did you wish to express with your drawing?

There are times when the world seems too big for me and my actions, and in others, it seems possible to modify it and interact with our planet, in fact. That's what I wanted to convey with my drawing.

Which new experiences came through your participation in the competition?

It was very important because it brought me assurance. In addition, new horizons have been opened, new visions of how things can be, many possibilities for improvement; and to make an impact with our art.

What motivated you to enter the competition?

I wanted to find out how good am I at drawing because I have never participated in a competition like that before. I love drawing maps, especially about Earth and transportation maps about my hometown, Budapest. I didn't expect that my picture would be selected as one of the best pictures from my country.

Which message did you wish to express with your drawing?

It's not really about the picture, it's about my life. Everybody has a dream, and my dream is that I'd like to be an architect. As a child, I can build things only with Legos, but one day I will build real houses. The picture also shows my place in the world by the mini figure with the flag and expresses my hobby that I'm obsessed with.

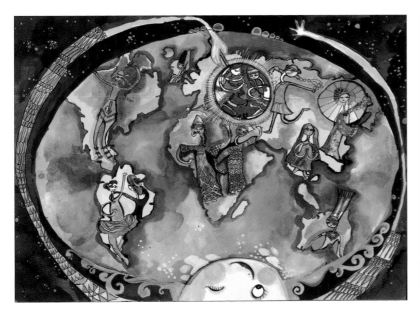

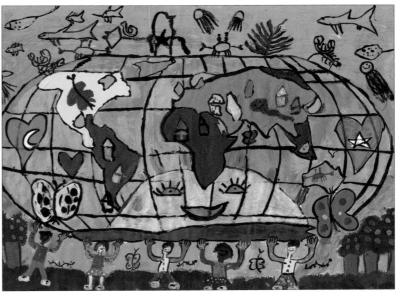

Ada Maria Ciontu, 9
Romania
2013
Happy Earth Is Music to Our Ears

Altuğ Namık Yavaş, 8
Turkey
2013
The World of My Dreams

What motivated you to enter the competition?

I like drawing and painting and I like participating in art competitions because they usually have a theme I need to read about, and this is how I learn. All the drawings work like a puzzle in helping me to find more creative ideas.

Which message did you wish to express with your drawing?

Initially, I just wanted to draw a map of the world, and I saw in books that it can be drawn either by putting all animals all together, or people, or towns, or weather. So, I thought of an original way to draw the map by putting people from different parts of the world in their national costumes dancing at a universal parade. It was at that moment when I saw that people are happily enjoying each other through music, and the message is that the world can be a happy place if we sing and dance and enjoy each other.

What motivated you to enter the competition?

My visual arts teacher, whose name is Canan Bülbül, encouraged me to enter the competition.

Which message did you wish to express with your drawing?

My topic was my dreamed world. While I was making this up, I thought about our freedom, our life, and our happiness. There should not be only life in the world, there should be enthusiasm and entertainment, since without them everything in the world would be unhappy. I was very happy to participate in this competition and also to make the picture; but I was feeling upset to attend such competitions. I beat my fears with this competition.

A biographical note

Barbara Bartz Petchenik

Barbara Bartz Petchenik (1939–1992) was a pioneer in the world of cartography. From 1965 to 1987, she conducted research and wrote more than a dozen articles and reports about a topic that was of considerable interest to her throughout her life: maps and atlases for children. For her contribution to this field, the International Cartographic Association (ICA) named the Barbara Petchenik Children's World Map Competition in her honor in 1993.

Barbara Bartz was born on August 17, 1939, in rural northern Wisconsin. Her family was well established and highly respected in the community. She grew up in a secure and nurturing environment that gave her the necessary self-confidence to achieve. By the time she was in high school, "the Bartz girls" (Barbara and her seven cousins—there were very few boys in the family) were recognized as achievers and leaders, both academically and socially. Though, in Barbara's words, her achievement was "more the former than the latter," as she "was never a prom queen."

In 1961, Barbara obtained a bachelor of science degree from the University of Wisconsin-Milwaukee with a major in chemistry and a minor in English. She spent the following year working at the university as a geography instructor, and in September 1961 served as the founding "map librarian" of the university's new Map and Air Photo Library. In 1962, she was awarded a National Defense Education Act Fellowship and entered the graduate program at the university. She intended to obtain a PhD in physical geography, concentrating on soils, with the ultimate goal of teaching at the university level. However, after earning her master's degree in 1964, she became a cartographic editor with the Field Enterprises Educational Corporation in Chicago. During her time there, she designed, conducted, and analyzed the research needed to produce maps and other material for the 9-to-14-year-old audience of the *World Book Encyclopedia*.

In 1970, after earning her PhD, Barbara accepted a five-year position at the Newberry Library as cartographic editor. Here, she planned, designed, and produced the *Atlas of Early American History* with editor-in-chief Lester Cappon and a staff of historians. From 1975 until her death in 1992, she served as the senior sales representative of cartographic services for the R. R. Donnelly and Sons Company. In her writing, she continued to pursue her interest in education.

Barbara wrote several articles and reports about maps for children from 1970 to 1987. Her work explored fundamental aspects of atlases for children by informally considering particular atlases. She thoughtfully observed

> Maps are mostly far too complex to "learn" at one or even many glances. The only way
> to try to make sure that children leave school with some idea of the relative shapes and
> sizes and arrangements of labeled earth areas and features is to provide opportunities
> for them to see and use these images (maps) on a highly repetitive and (I happen to prefer)
> structured basis.[1]

Barbara did much of her research about maps for children during her tenure with Field Enterprises. During the process of designing maps for the *World Book Encyclopedia*, she collected empirical evidence on which types of maps children preferred and could most easily understand, and used this evidence as a basis for her map design. She interviewed a thousand elementary school children and invited them to interpret alternative styles of small-scale maps. From this work, she identified difficulties children had with the interpretation of scale, coordinates, symbology, and typography. Her research showed that children valued clarity in cartography and liked less-cluttered maps with more clear spaces. She noted that although teachers claimed map use was an important skill, children were rarely taught how maps worked. Above all, she recognized that children are a large and important group of map consumers, that they do not approach maps in the same way as adults, and that their distinct perspectives should be taken into account in the process of map design. The articles and research publications in the bibliography that follows provide opportunities to learn more about her philosophy on cartography, especially as it relates to children.

Barbara was active in many professional organizations, including the American Congress on Surveying and Mapping's (ACSM) American Cartographic Association, the Association of American Geographers, the Society of Automotive Engineers, and the International Cartographic Association. She also served as a member of the editorial board of *The American Cartographer*. Through her efforts, the ACSM Map Design Competition began giving awards for student-designed maps. She served as a member of the US National Committee to the International Cartographic Association. She participated in several ICA activities over the years, and in 1991 at the General Assembly in Bournemouth, England, she was the first woman to be elected vice president of the ICA.

Over the nearly twenty years that I knew Barbara, I was always impressed by her intelligence and good humor. We enjoyed a lively camaraderie over the years. Her presence, scholarly contributions, and spirited intellectual discussions have been and will continue to be missed. The Barbara Petchenik Children's World Map Competition is a fitting way of keeping her alive in our memories.

Alberta Auringer Wood (with assistance from Patrick Wiegand)

[1] Fundamental considerations about atlases for children. 1987. *Cartographica* 24:16-23.

Works by Barbara Bartz Petchenik about children and maps

"Cartography for Children: A Research Approach." 1971. *La Revue de Geographie de Montreal* 25: 407–10.

"Designing Maps for Children." 1971. *Cartographica* monograph 2:35–40. Presented at the Symposium on the Influence of the Map User on Map Design at Queen's University.

"Evaluation of Two-Color Political Maps in *World Book* (Chad, Singapore, Sierra Leone, Formosa, Nigeria)." 1967. Research report for Field Enterprises Educational Corporation, Chicago, 43.

"Experimental Use of the Search Task in an Analysis of Type Legibility in Cartography." 1970. *Journal of Typographic Research* 4 (Spring): 102–08. Reprinted in *The Cartographic Journal* 7 (2): 103–12.

"Facts or Values: Methodological Issues in Research for Educational Mapping." 1984. Paper presented at the Twelfth Conference of the International Cartographic Association, Perth, Australia, August 6–13. *Technical Papers* 1: 788–804. Reprinted as essay 2 in "Value and Values in Cartography," *Cartographica* 22 (3): 20–42.

"Fundamental Considerations about Atlases for Children." 1987. *Cartographica* monograph 36, 24 (1): 16–23.

"Map Design for Children." 1965. Research report for Field Enterprises Educational Corporation, Chicago, 224.

"Map Type: Form and Function." 1966. Research report for Field Enterprises Educational Corporation, Chicago, 145.

"Maps and Children." 1971. Letter in *Journal of Geography* 71 (2): 68.

"Maps in the Classroom." 1970. *Journal of Geography* 69 (January): 18–24. Reprinted in *Social Science and Geographic Education: A reader*. 1971. John M. Ball, John E. Steinbrink, Joseph P. Stoltman, eds. New York: John Wiley and Sons, Inc.

"Nature of Research in Education." 1972. *Journal of Geography* 71 (4): 215–32.

Review of *Junior Atlas of Alberta* by J. C. Muller and L. J. Wonders. 1981. *The American Cartographer* 8 (1): 83–5.

Review of *Junior Atlas of Alberta Teachers Manual* by W. C. Wonders. 1981. *The American Cartographer* 8 (1): 83–5.

"Search: An Approach to Cartographic Type Legibility." 1969. *Journal of Typographic Research* 3 (4): 387–97.

"Type Variation and the Problem of Cartographic Type Legibility. Part One: Cartographic Typography as a Medium for Communication; The Cartographic View of Legibility." 1969. *Journal of Typographic Research* 3 (2): 127–44.

"What about Illinois? Or, Children and a Reference Map." 1967. Research report for Field Enterprises Educational Corporation, Chicago, 71.

Works about Barbara Bartz Petchenik

Krejcie, Valerie Wulf. 1990. "Barbara Petchenik." *Progress and Perspectives: Affirmative Action in Surveying and Mapping* (September–October): 3.

Krejcie, Valerie Wulf, Leona Sorenson, Richard E. Dahlberg, and Joel L. Morrison. 1992. "Barbara Bartz Petchenik: An Appreciation." *ACSM Bulletin 139* (September–October): 24.

Morrison, Joel L. 1992. "Barbara Bartz Petchenik: In Remembrance." *Cartographica* 29 (2): 60–1.

Robinson, Arthur H. 1994. "B. B. Petchenik (1939–1992)." *Imago Mundi* 46: 174–5.

Rundstrom, Robert A. 1992. "Barbara Bartz Petchenik: A Personal Appreciation." *Cartographica* 29 (2): 60–1.

Taylor, D. R. Fraser. 1992. "Barbara Bartz Petchenik: In Remembrance." *ICA News* no. 2: 7. Reprinted in *The Cartographic Journal* 29 (2): 160.

Resources

The Barbara Petchenik Children's World Map Competition is a biennial map design competition for children ages 15 and younger hosted by the International Cartographic Association (ICA). Each submission should graphically represent the theme of that year's competition. For more information on the ICA, the competition, and where to access examples from past competitions, please see the following websites.

The International Cartographic Association is the world authoritative body on cartography and organizer of the Barbara Petchenik Children's World Map Competition: http://icaci.org.

The ICA Commission for Cartography and Children provides consultative support on rules and judging of the competition. Rules and guidelines for the competition can be found on the commission's website: http://lazarus.elte.hu/ccc/ccc.htm.

Carleton University Library in Ottawa, Canada, archives submissions from past international competition winners and makes them available for viewing: http://children.library.carleton.ca/.

Esri Press publishes a number of editions of the *Children Map the World* series. Information on how to purchase books from this series is posted on the Esri Press website: esri.com/esripress.

Index by participant country of origin